IMAGES of America
MOTORCYCLING IN SANTA BARBARA COUNTY

*For Bob
Best Always,
Ed Janss*

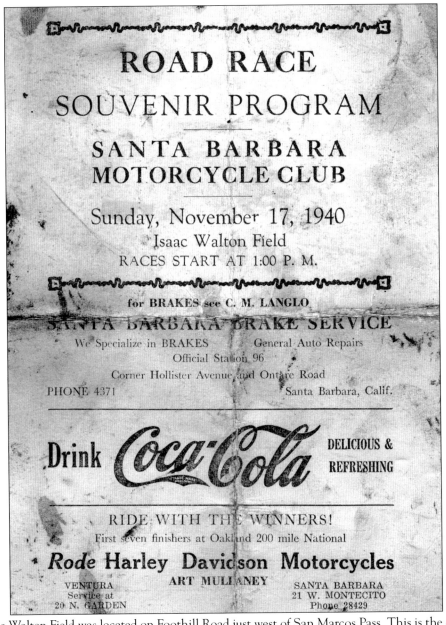

Isaac Walton Field was located on Foothill Road just west of San Marcos Pass. This is the cover of a program for a road race event held there in November 1940. Inside, the entrants are listed as Elmer Black, James Reinesto, Clarence Langlo, Ken Mullaney, Ernest Snow, Pint Wadell, J. Herkimer, Walter Docker, Bob Mullaney, Philip Cordero, Harry Smith, Jimmy Lee, Tom Smiley, Fritz Vier, and T. Hanson. (Courtesy of Phyllis Black.)

ON THE COVER: Several historic elements can be seen in the background as referee and flagman Clarence Langlo signals the start of a motorcycle race at Pershing Park. Behind him is the roofline of a garage once used to store Santa Barbara's trolley cars. Behind the eucalyptus trees was the former site of the Dibblee Mansion (demolished in 1932) and is now the home of Santa Barbara City College. (Courtesy of Ed Langlo.)

IMAGES of America
MOTORCYCLING IN SANTA BARBARA COUNTY

Ed Langlo and Tony Baker

ARCADIA
PUBLISHING

Copyright © 2016 by Ed Langlo and Tony Baker
ISBN 978-1-4671-1723-4

Published by Arcadia Publishing
Charleston, South Carolina

Printed in the United States of America

Library of Congress Control Number: 2016939197

For all general information, please contact Arcadia Publishing:
Telephone 843-853-2070
Fax 843-853-0044
E-mail sales@arcadiapublishing.com
For customer service and orders:
Toll-Free 1-888-313-2665

Visit us on the Internet at www.arcadiapublishing.com

This book is dedicated to all the members of the Alumni Club for their extensive contributions to its content.

Contents

Acknowledgments		6
Introduction		7
1.	The Early Days	9
2.	The Courses	37
3.	The Shops	65
4.	The Clubs	81
5.	The People That Made It Happen	91

Acknowledgments

I first want to offer my sincere thanks to someone who was there at the onset and at age 92 is still assisting me in assembling this book. Rutledge "Putty" Mills has been invaluable in my bid to preserve Santa Barbara's motorcycling history. And to all the members of the Alumni Club—many of them posthumously—thank you for being there. Walter Docker, Tony Rios, Howard Mills, Bob Mullaney, Jim Mills, Donald Crawford, Bob Snow, and Paul Lopez, thank you for allowing me access to your photo albums, news articles, race programs, and especially the memories and firsthand stories of the way it was. A special thanks goes to my better half, Teri, for her patience and assistance with the page and chapter layout. Phyllis Black, for all of your and Bud's history, thanks for the memories. Marsha and Maureen, thank you for all the Mullaney history. Bill Shalhoob and Michele Hoffman, thank you for all your help. My thanks are extended to Katherine McCracken for her close reading of the text. K.C. Kenzel and Dave Blunk, thanks for providing so many photographs. Gil Trevino, thank you for all your tech support. Trevor Dunne and Sheryl Schroeder, thank you for your enthusiasm and access to Mullaney's. Jeanne La Berge Rios, thanks for all your support. Michael Redmon of the Santa Barbara Historical Museum, thank you for assisting in research. Thanks go to my coauthor, Tony Baker, for initiating this whole process. Special thanks go to D. Rocky for technical advice. I would like to express my gratitude to Matt Todd, Stacia Bannerman, and all the staff at Arcadia; without you, our book could not have come to fruition.

Introduction

The elderly gentleman with thinning white hair is sitting intently in an Adirondack chair on the covered wooden porch of Silver Crest retirement home. Hanging on his fervent words is a thin, bright-eyed lady resident in a motionless porch swing. "I shifted all my weight to the kick starter," he said, "and the engine roared to life. I felt the vibration through the handle-grips, then twisted the throttle beyond my comfort level, but the increasing wind in my hair urged me on to higher speeds. I hear that fading thunderous sound in my dreams most every night. If I had but one more chance, if I could go back and change just one thing, I would go back to my youth and buy that Harley-Davidson."

Most of us commiserate when reading such a tale. The people, places, events, and racetracks expounded on in the following pages are of the cut that lived that dream.

In the days before World War II, there were no computers or Internet to while away your time on. There were no televisions and most telephones were on a party line and permanently attached to a wall. America was in the midst of a depression, but the spirits of its people were on another course. People were often forced to improvise. You had to create your own activities, and on the central coast of California, fast motorcycles were an exciting means of doing just that. One of the first Harley dealers in Santa Barbara, located at 21 West Ortega Street, was operated by James Slaybaugh (who in 1947 would usher in the Carpinteria Thunderbowl). Slaybaugh's establishment appears in the 1915 *City Directory* as "Agent the Harley-Davidson." In the early 1920s, Harley-Davidson Sales Company was located at 102 East Haley Street. In 1931, Francis Arthur Mullaney would open the doors of his dealership at 223 Anacapa Street. He moved to 21 West Montecito Street and was followed in 1945 by John Gales Motorcycle Shop at 222 Helena Avenue, while Mullaney's transitioned to Indian motorcycles. Swede's Motor Sports Center emerged as the Harley dealer around 1949 at the northeast corner of State Street and La Cumbre Road before relocating to 19 West Gutierrez Street.

In 1924, Harley-Davidson and Indian motorcycle enthusiasts united to form the Santa Barbara Motorcycle Club. The new club held American Motorcycle Association (AMA) charter number 35. To put that into perspective, the Los Gauchos motorcycle club, also of Santa Barbara, registered with the AMA on September 16, 1949, and was issued number 1566.

If you listen to the firsthand stories of the men who lived those times, they will tell you about the good old days. Imagine yourself for a moment sitting in a dimly lit steak house, in a booth with diamond-tufted red vinyl upholstery, known by most locals simply as Harry's. It's a gathering of old friends and surviving members of the original Santa Barbara Motorcycle Club, now known as the Alumni Club. The men at the table are 80 to 90 years old, with white hair and scars to prove that they rode motorcycles in competition, some professionally. Ninety-one-year-old Walter Docker is reliving an incident during the Gibraltar Dam Endurance Run in 1937, when a car came over the hill from the Santa Ynez Valley north of Santa Barbara and ran two competitors off the road. He says that in the early 1930s, the competition started at the base of San Marcos Pass, running

several miles up the winding public road to Gibraltar Camp. That's when 85-year-old Rutledge "Putty" Mills, a seasoned veteran, stops him and says, "It started where?" It's evident right then that someone has to preserve this part of history, or when these veterans pass away, they'll take with them the knowledge and stories of those early days.

The pages of this book are an effort to do just that—preserve the good old days. What was it like to start up the switchbacks of the old stagecoach route (now San Marcos Pass) at the stroke of midnight in January in a timed endurance run to Gibraltar Dam? How exhilarating was it to ride at Pershing Park Stadium on a Harley-Davidson version of a speedway bike with the end of a Studebaker bumper strapped to your left foot for a skid plate? Didn't you need a permit to put on event of that caliber in a city park?

Hear the answers from the men who rode those motorcycles. Though some of the meets were, as Walter Docker put it, "clandestine," the highway patrol and the city fathers wanted the competition off the streets and would actually sanction and promote the meets.

Times would soon change. After the war came television to entertain you, and there were ordinances to comply with. Not one of the motorcycle courses in Santa Barbara County described in this book survived these changes: the Carpinteria Thunderbowl, La Conchita Hill Climb, the stadium at Pershing Park, Veronica Springs (now Elings Park), the Lemon Packing House Track, and Fox Canyon Tourist Trophy course all faded into history. The thunderous roars of the Harley-Davidson and Indian motorcycles at full throttle to prove who was the fastest are silenced. When we recall the past, we remember the good times and forget the times that were not so good. The sky was bluer, the summers were longer, and the days were somehow better. Were the good old days really better? You decide as you read the pages and thumb through the many photographs of this book, *Motorcycling in Santa Barbara County*.

—E.C. Langlo

One
THE EARLY DAYS

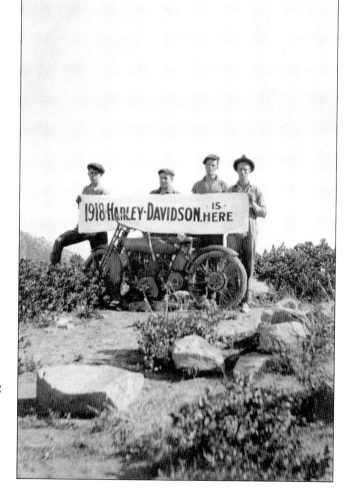

The earliest motorcycle organization in Santa Barbara known to the writer was the Santa Barbara Motorcycle Club (SBMC), formed in 1924. This image was captured six years prior to that. This Harley-Davidson has already been modified for hill climbing with bands clamped to the rear wheel, and the banner sums up the statement: Harley-Davidson was king of the hill. (Courtesy of Santa Barbara Motorcycle Club.)

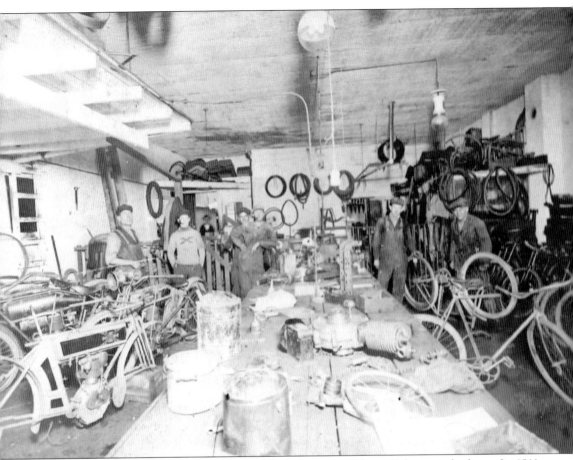

This image was captured sometime around 1915 in one of Ignaz Schwinn's facilities. In 1911, Schwinn purchased Excelsior Motorcycle Works and began producing motorcycles along with the now legendary Schwinn bicycles. On the tank of the front motorcycle, the Excelsior Auto Cycle logo is clearly seen. The two rear motorcycles appear to be of 1913 vintage, but the bike in the foreground with the Excelsior insignia looks to be a 1909, built two years before Schwinn bought the company, lending credence to the thought that this is not a manufacturing facility but possibly a repair shop. In 1931, with sales plummeting, Schwinn ceased production of his Excelsior line of motorcycles for good. Standing at the far left is Francis Arthur Mullaney, who would in 1931 open a Harley-Davidson dealership in Santa Barbara at 219 Anacapa Street. In 1934, he relocated to 21 West Montecito Street, where he remained in business until his passing in 1961. (Courtesy of Marsha Mullaney Novak.)

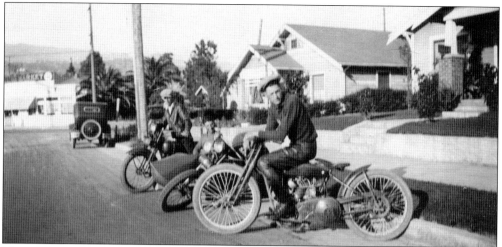

This view shows Forrest "Fory" Ames (foreground) and two unidentified friends parked on what appears to be Santa Barbara's west side in the mid-1920s. Fory sits astride the tank of his stripped-down and bobbed early-1920s Harley-Davidson. The snap-brim cap and turtleneck sweater were common attire for motorcyclists in the 1920s. Note the individual in the sidecar at center. (Courtesy of SBMC.)

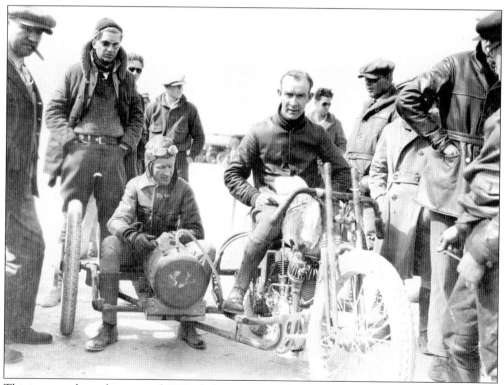

This is a snapshot taken around 1930 of what appears to be a modified 1929 Harley-Davidson JDH. The sidecar chassis has been fitted with an auxiliary fuel tank for endurance runs. Endurance records were a popular goal in the 1920s and 1930s with riders like Reggie Pink and Fred "Iron Man" Ham. In 1936, Ham set a record of 1,825 miles in 24 hours at Muroc Dry Lake in California. (Courtesy of SBMC.)

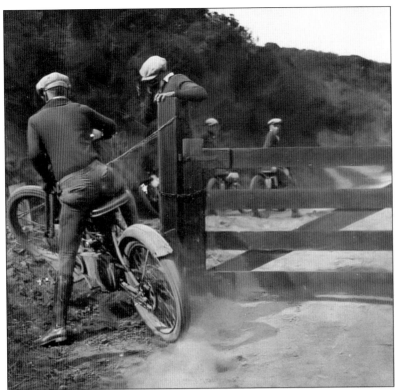

A handful of the more adventurous members of the club meet up for a trek up the old stagecoach road to a place they have heard stories about since grammar school—Slippery Rock. Sometimes called the toll road, this place is on private land, and getting up there will not be easy. There are locked gates, narrow passages, steep climbs, and the stories told about the owner. (Courtesy of SBMC.)

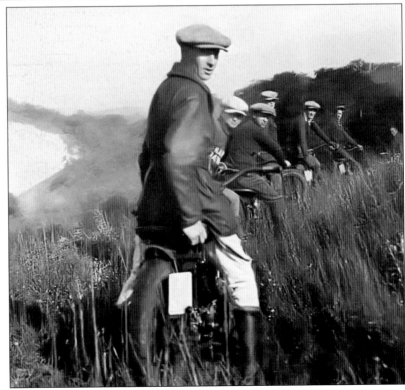

Things are looking better for the boys, and the view of the Goleta Valley from this ridge is fantastic. It is 1926, and Goleta is almost all farmland. The lemon groves and bean fields stretch out like a patchwork carpet below. They will have to push on if they are going to find the fabled Slippery Rock. (Courtesy of SBMC.)

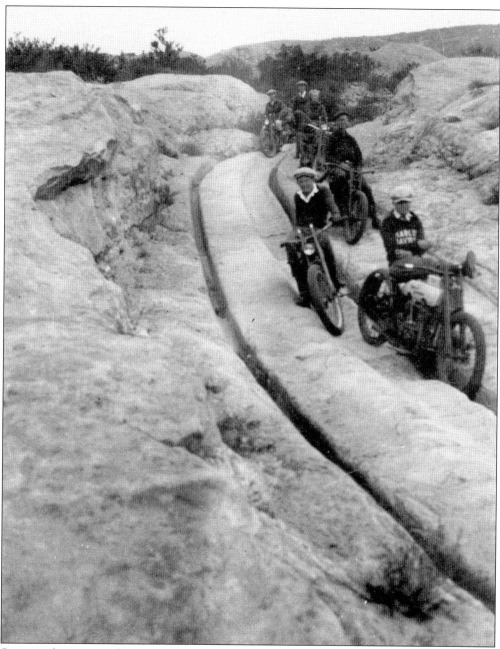

Stagecoaches serving the Santa Barbara and Goleta area would traverse the Santa Ynez Range by way of this sandstone monolith from 1861 to 1892. This section of the passage was treacherously slippery for the steel horseshoes and wagon wheels, hence the name. Chinese work crews chiseled three-inch-deep ruts to stabilize the coaches and cross-hatched grooves for the horses. Over time, the steel-clad wagon wheels would cleave these ruts to a depth of up to 12 inches. Too often, the stagecoach drivers would forget to close the gates near what is now Fairview Avenue, and Thomas Lillard's cattle would wander. In 1892, he revoked permission to cross his ranch. The route was moved east, and the stage line continued until 1901 over what would become known as San Marcos Pass. (Courtesy of SBMC.)

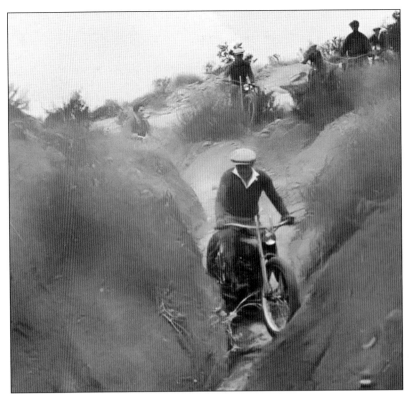

The voyage home appears to be more daunting than the trek up the hill. The rest of the guys seem to be watching to see if that Harley can make it through a rock crevice going downhill before they even move. (Courtesy of SBMC.)

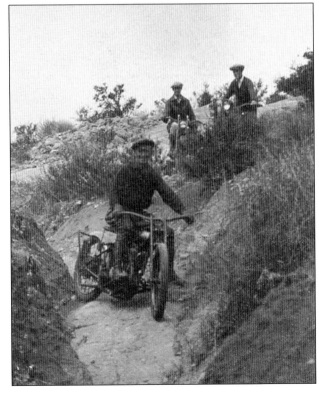

The shortcut works and the smiles are back. It was a good day—no, it was a great day—and it likely will not be replicated anytime soon. Slippery Rock really did exist, and the Santa Barbara Motorcycle Club boys would make it home with stories they surely told for the rest of their days. (Courtesy of SBMC.)

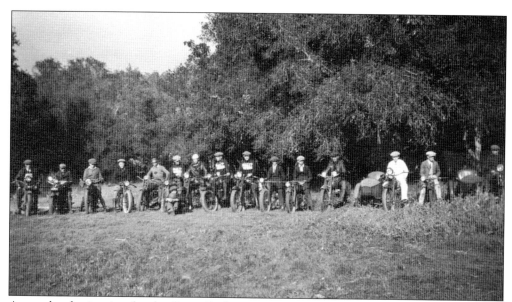

A popular destination for the Santa Barbara Motorcycle Club in the early days was Meiners Oaks, near Ojai, California. The boys are lined up here for a group photograph on one of those outings in the late 1920s. It is said that in the 1870s, John Meiners, a Milwaukee brewer, acquired as payment of a debt the land that would become Meiners Oaks. (Courtesy of SBMC.)

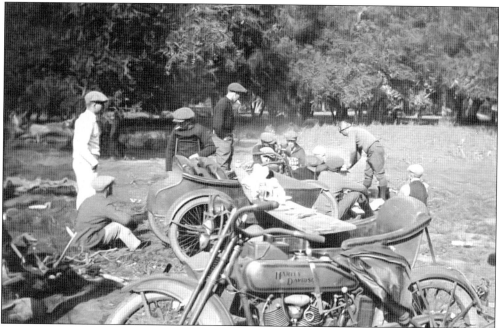

Life is somehow simpler in the 1920s, and John Meiners's beloved oak groves are perfect for an impromptu cookout. Improvisation provides a sufficient picnic table, with a board from the old ranch laid across two sidecars. John Meiners would spend much of his time in the Ojai Valley until his passing in 1898. His original house still stands and is part of Happy Valley School. (Courtesy of SBMC.)

One of the most notable themes in these early images is the riders' apparel. Snap-bill caps take the place of helmets, and even in what appears to be a lineup for a three-wide drag race, a white shirt and tie was appropriate. Note the unique kickstand used for the motorcycle on the left. (Courtesy of SBMC.)

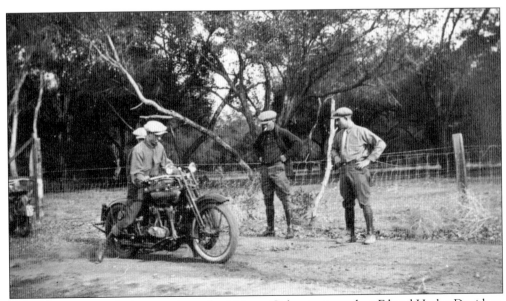

Things are getting a little too quiet at the Meiners Oaks picnic, and an F-head Harley-Davidson at full throttle is just what is needed to get the guys going again. His friend in the white tie seems to be saying: "How are you going to get back to Santa Barbara if you break that thing?" (Courtesy of SBMC.)

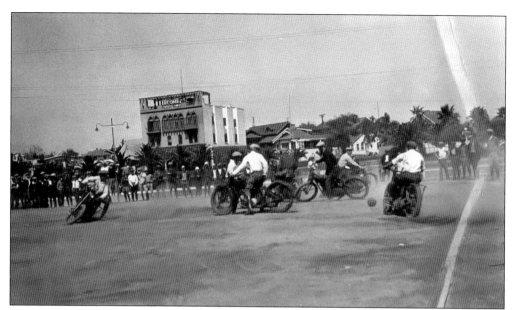

Motorcycle polo became very popular in the 1920s, and the Santa Barbara boys ventured all the way down to Venice, California, to challenge their south coast rivals. The ball is wide open and about to be kicked hard by the uncovered rider on the far right. The hazards were obvious, and the toughest team was said to be the Santa Monica Polo Club. (Courtesy of SBMC.)

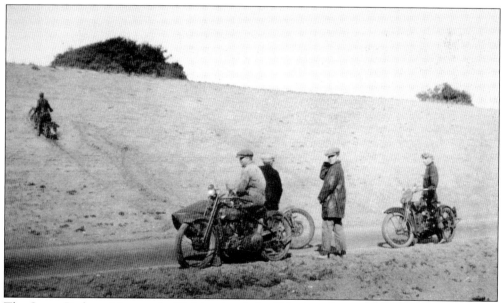

The Santa Barbara Motorcycle Club initiated the Gibraltar Dam endurance run on the first Saturday in 1925. This image, from one of the first of those runs, catches the boys fooling around on the way home on an impromptu hill climb course. Fory Ames was unrivaled in the inaugural year of 1925, and after Mike McDonough took it in 1961, the first Saturday after New Year's Day fell silent. (Courtesy of SBMC.)

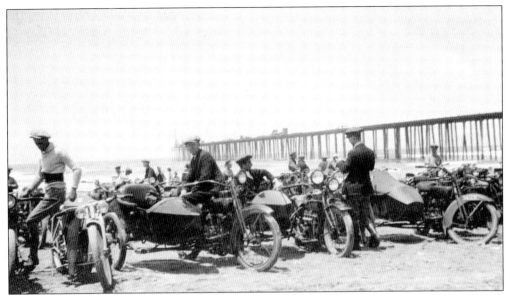

Sam Holmberg sits sideways on his sidecar-equipped Harley-Davidson in the sands of Pismo Beach on what was probably the first rally attended by the Santa Barbara Motorcycle Club. The year is 1924, the same year the club was formed. Notice the abundance of headlights and the Henderson four-cylinder inline engine of the bike to the right of Holmberg. (Courtesy of SBMC.)

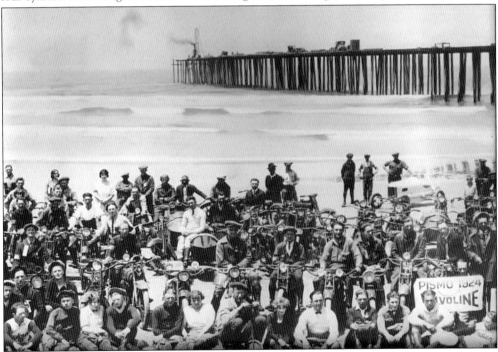

The Pismo Beach pier was dedicated in 1924, but in this image it is clearly still under construction, with the pile-driver at work out at the end of the structure. Because of the central coast location, Pismo and the surrounding communities were well known for motorcycle rallies and races. Note the sign in the lower-right corner declaring "Pismo 1924, Valvoline," and the roadster above it. (Courtesy of Pismo Beach Public Works.)

For Sam Holmberg, the 1920s were an untroubled time of blue skies and green lights. He seems to have traveled far and wide whenever adventure or his sidecar Harley-Davidson enticed. This image has captured him in the sequoias, standing beside one of the real giants of the early days. (Courtesy of SBMC.)

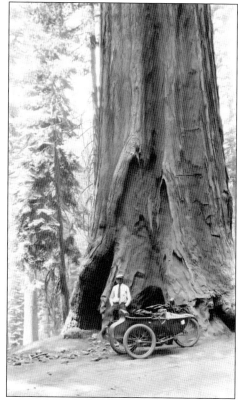

The omnipresent Sam Holmberg shows up in more images in more far-flung locations than anyone else in the old photo album. He owned the Harley dealership, and under this picture, Forrest Ames wrote: "Sam Holmberg, a swell guy." (Courtesy of SBMC.)

It's a sunny day at Hendry's Beach, there are no beachgoers in sight, and the smell of the salt air on a light breeze is too tempting for C.W. Smith. It's time to spin some circles in the wet sand. In the 1920s, vehicles were often seen cruising the beaches for pleasure and necessity. (Courtesy of SBMC.)

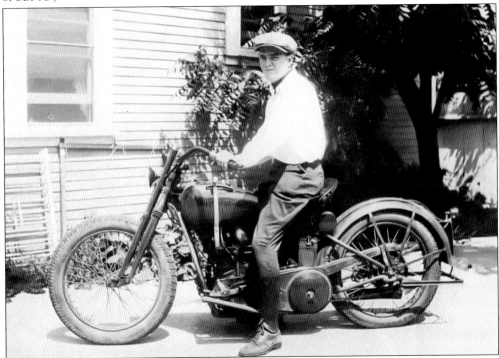

Charles W. Smith sits on a late-1920s Harley-Davidson model J beside his home at 630 Anacapa Street. He was known by fellow club members and is listed in the club photo album simply as "Smitty." At the time of this writing, the house in this image is still standing, but is slated for demolition. (Courtesy of SBMC.)

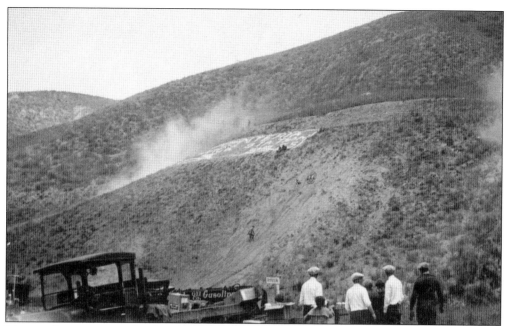

It's a somber moment at La Conchita. A man can be seen climbing what looks to be a practice course. Directly above him is a downed motorcycle, and to the left of that bike is the rider in a fetal position, no doubt in a lot of pain. The lack of safety gear is obvious in these early images. (Courtesy of SBMC.)

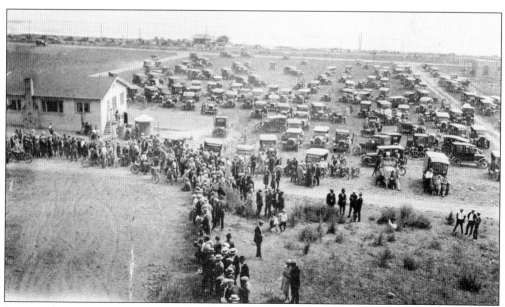

In 1925, the Santa Barbara Motorcycle Club held a hill climb event at an unsuccessful real estate subdevelopment project called La Conchita del Mar, located just south of the Santa Barbara–Ventura county line. The dirt road in the foreground is the present-day Vista del Rincon Drive, and Carpinteria Avenue is at right. (Courtesy of SBMC.)

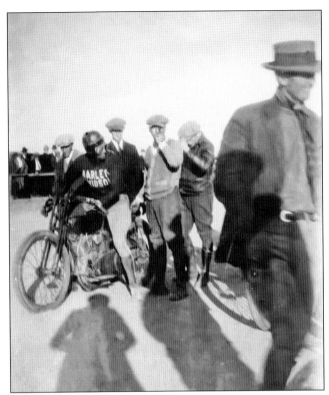

Here is an interesting shot of the pit area at Santa Maria's fairground racetrack in 1930. A group of young men in the fashions of the day crowds around a Harley-Davidson J model and its rider. The individual at right is an example of how the typical young "blade" of the central coast dressed back in the day. (Courtesy of SBMC.)

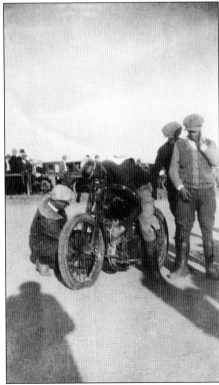

In this image, the relaxed scene has changed to one of concern as the rider and one of the crew lean down and turn their attention to the engine. As they appear to be leaving the pits for the track, this would be a bad time to be having mechanical trouble. (Courtesy of SBMC.)

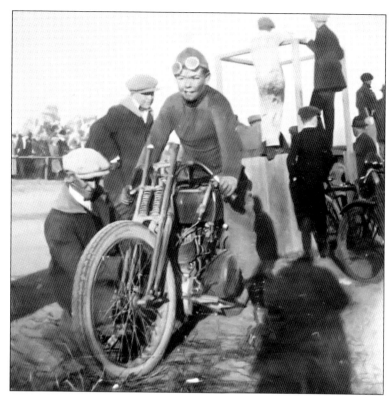

Displaying a confident grin, a youthful Bob Zegers is ready to race at the old horse racing track at Santa Maria while a mechanic makes a few last-minute adjustments in this scene from the mid-1920s. Bob was an early member of the Santa Barbara Motorcycle Club. (Courtesy of SBMC.)

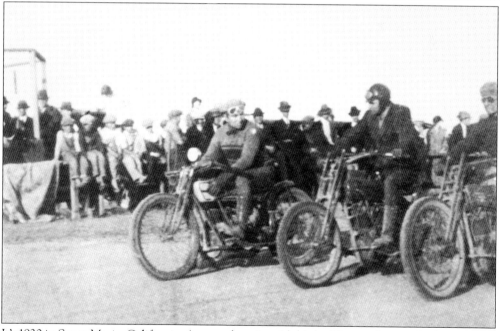

It's 1930 in Santa Maria, California. A young boy sits with his buddies on the guardrail, captivated by the men and their powerful machines lining up in front of him in preparation for contention over who is the fastest. Just the sounds of the engines command his attention, and he envisions the day when he will be big enough—and he will win the match. (Courtesy of SBMC.)

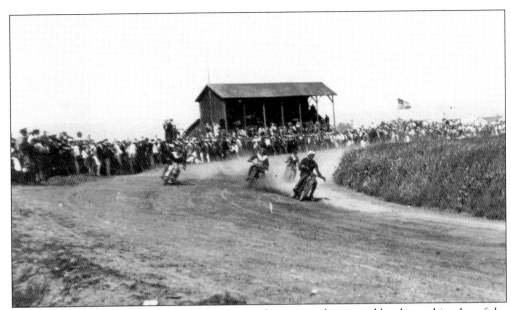

The horse racing track at Santa Maria fairground, now mostly covered by the parking lot of the present-day Santa Maria Fairpark, was a popular venue for flat-track motorcycle racing of all types. Note the old covered grandstand in the background of this 1930 image. The board-and-batten construction was typical of many large California buildings in the early 20th century. (Courtesy of SBMC.)

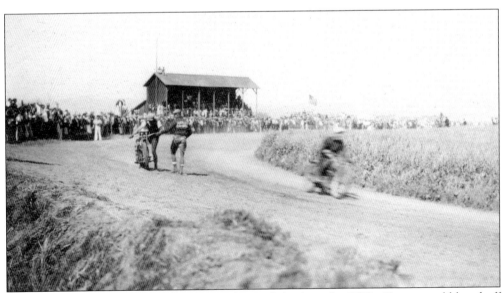

Relay racing was a common event on race-day cards back in the 1930s. Teams would hand off motorcycles instead of the batons used in foot relays. The camera has captured one team in the process of a rather poor change as a competing rider charges past. Note the two individuals visible on the roof of the grandstand. (Courtesy of SBMC.)

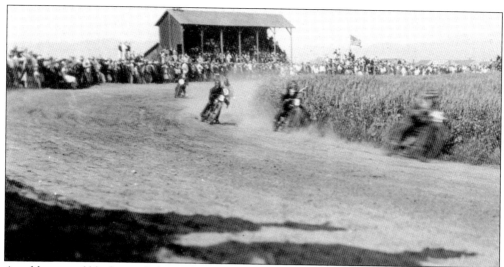
An old, tattered black-paged photo album filled with pictures of motorcycles was found at a garage sale and is believed to be an original SBMC collection lost for years. Fory Ames made entries in white pencil, apparently in his later years. Most of these early images were drawn from that book. Under this image, Ames wrote, "Santa Maria around 1930, pros." (Courtesy of SBMC.)

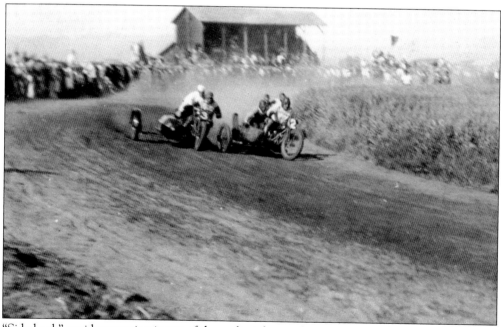
"Side-hack" or sidecar racing is one of the earliest forms of motor sport, with roots in early-20th-century England. It was fast and dangerous and was a surefire crowd-pleaser at fairs like this one at Santa Maria in 1930. The co-rider would shift his weight from motorcycle to sidecar in order maintain balance around curves, as seen here. (Courtesy of SBMC.)

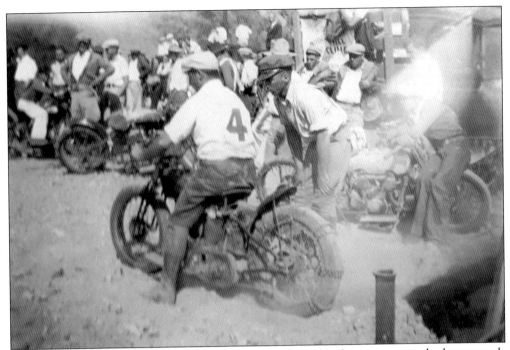

The tension is evident as rider No. 4 appears to be assisted by his pit crew in the last seconds before an attempt at the hill. The competitor, identified only as Joe in the photo album, is astride a Class-A hill-climber, evidenced by the double-row chain on the rear tire. (Courtesy of Clarence Langlo.)

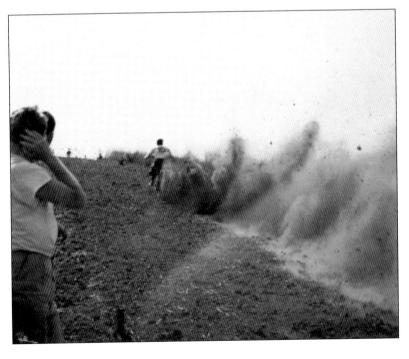

A contestant kicks up big rooster tails of dirt as he makes his way up the hill in this image from 1925. Those old Harleys and Indians could be plenty loud with their straight exhaust systems. The spectator at left with his hands over his ears obviously thinks so. (Courtesy of SBMC.)

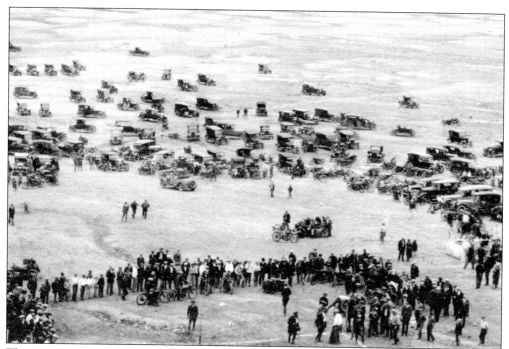

This interesting image from the late 1920s shows the busy pit and parking area at China Grade in Bakersfield. The photographer appears to have been partway up the course looking back towards the starting line. At lower center, four competitors can be seen in the staging area preparing to make an attempt at the hill. (Courtesy of SBMC.)

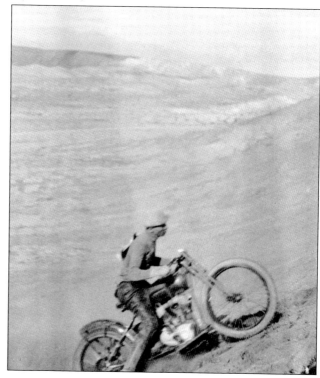

In this image from the mid-1920s, Lloyd "Sprouts" Elder is powering his Harley-Davidson up the hill climb at a place called China Grade, as noted on the original print. This is believed to be in the desert foothills northeast of Bakersfield near Highway 178. (Courtesy of SBMC.)

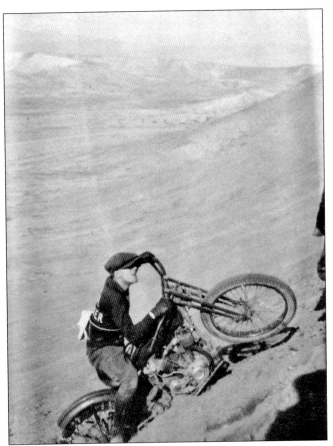

This rider is in trouble as his motorcycle gets stuck near the top of the hill. The front wheel is rising from the ground as the rear wheel digs deep into the sandy course at China Grade. The almond-shaped cam case cover suggests that this is a Harley-Davidson JDH Two Cam 74. (Courtesy of SBMC.)

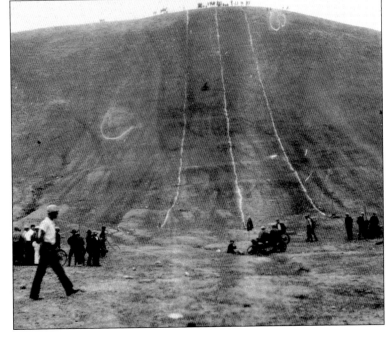

As is evident in this image, China Grade was a steep, sandy, stony hill at least 200 feet in height. Chalk lines can be seen marking the course. The irregular curved lines on either side appear to mark rocky outcrops. Just visible in the center is a rider. His bike is sideways on the track, so he must be having trouble negotiating the steep climb. (Courtesy of SBMC.)

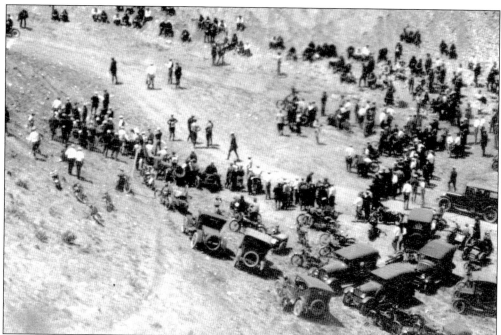

Hill climb events drew a lot of people in the old days, as this view of the crowded pit area at Girard shows. Note the large number of bikes scattered throughout the scene. An interesting variety of early-1920s cars are visible in the lower right foreground, and in the extreme upper left corner, a rider can be seen at the starting line. (Courtesy of SBMC.)

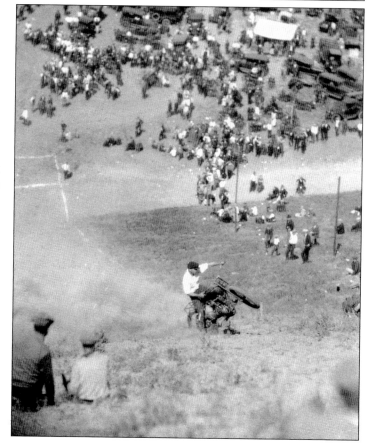

This image is inscribed "Ya gotta be good," and riders certainly had to be good to make it up the hill at Girard. This young rider looks like he is about to prove his skill one way or another as a group of spectators looks on at left. Note the chalk lines marking the course at left center. (Courtesy of SBMC.)

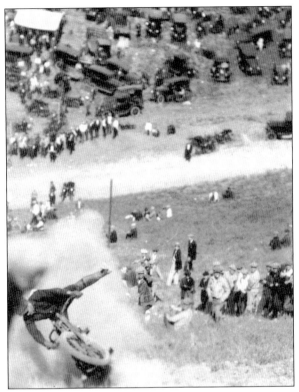

These hill climb images were taken in the 1920s, when the bikes were somewhat unregulated. It was "run what you brung," and it was not for the faint of heart. The factories built special-purpose motorcycles for hill climbing, and the riders would fit the rear tire with snow chains for what could be violent traction. In 1933, Harley-Davidson and Indian joined in the effort to create a hill climb competition known as Class-C. These were basically stock bikes, and during the Depression, the average enthusiast could buy a motorcycle on Saturday and go racing on Sunday. (Both, courtesy of SBMC.)

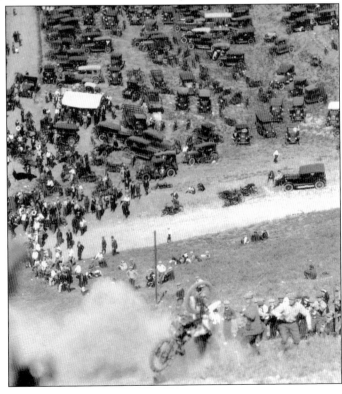

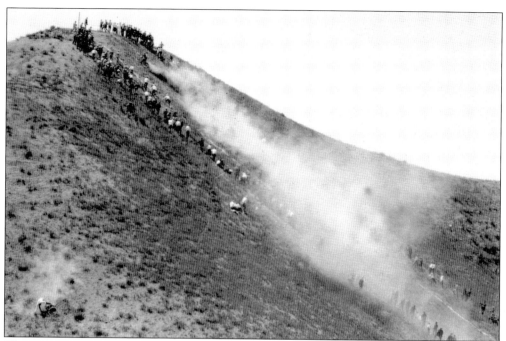

This image gives a good view of the top of the hill climb at Girard. A contestant can be seen kicking up a cloud of dust as he nears the top, but the real action is visible in the lower left corner. An unfortunate rider can be seen going over his handlebars as he dumps his bike while descending the hill. (Courtesy of SBMC.)

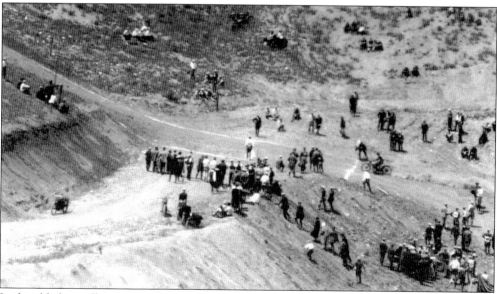

In the old photo album, Fory Ames wrote "the last one at Girard" under this image. He may have meant the last rider of the meet, the last time he went to Girard, or the last event held there. It will probably never be known, but this is too good a shot not to include in this collection. (Courtesy of SBMC.)

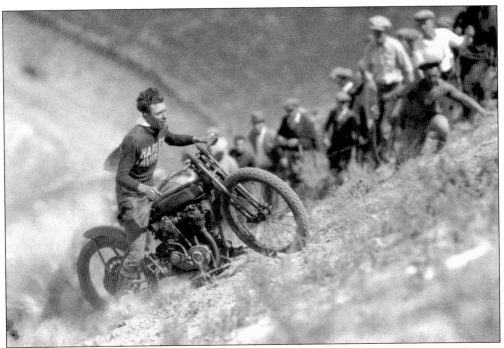

Another well-known competitor at Girard was "Wild Bill" Crane of San Francisco, seen here as he nears the top of the hill. Crane is on a 74-cubic-inch Harley-Davidson two-cam model JDH. These J models were said to have domed magnesium-alloy pistons. (Courtesy of SBMC.)

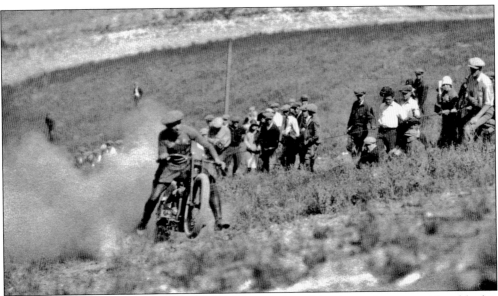

Lloyd "Sprouts" Elder of Fresno was a well-known rider of the day and was considered by his peers to be "awfully good." Sprouts is seen here early in his run up the hill at Girard. Although the crowd in the background consists mostly of men, a few women spectators are also visible. (Courtesy of SBMC.)

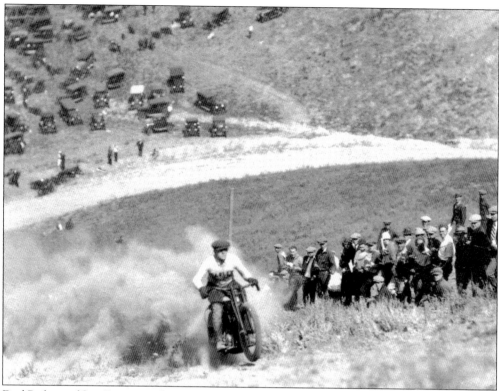

Dud Perkins of San Francisco shows excellent form as he nears the top of the hill at Girard on his Harley. His skilled style of riding earned him the nickname "Ye Old Maestro." Indian had changed to the better-performing side-valve or flathead engine design, while Harleys (like the one in this image) stayed with the intake-over-exhaust F-head through 1929. (Courtesy of SBMC.)

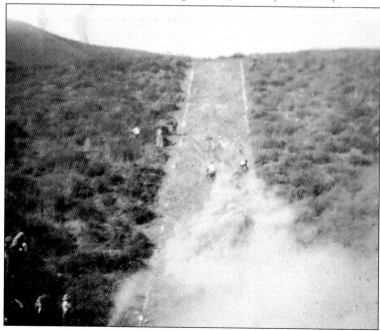

At some hill climb events, two competitors would attempt the embankment at the same time. These events were often referred to as drag-race hill climbs, and as displayed here, the dust would really fly. By the shape of the dust trails and trajectory of the bikes, these two may have just collided. (Courtesy of SBMC.)

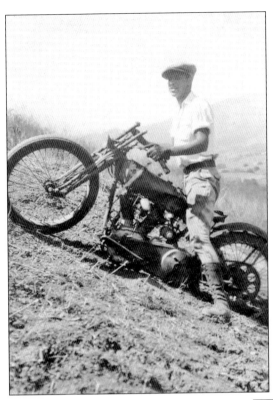

This image shows Pat Philips in a real predicament on the first hill climb course in Santa Barbara. A run known as the Big Hill at Veronica Springs was on the west side of Las Positas Road. It appears that Philips is attempting to ride the motorcycle out of the rut he has created. (Courtesy of SBMC.)

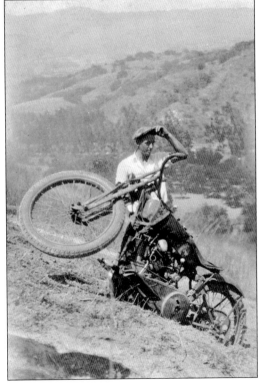

The early-1920s Harley-Davidson has chains on the rear tire for added traction, but when a chained wheel slips, it will dig a hole in short order. Pat has given up in disgust, the frame is on the ground, and the Big Hill has claimed another victim. (Courtesy of SBMC.)

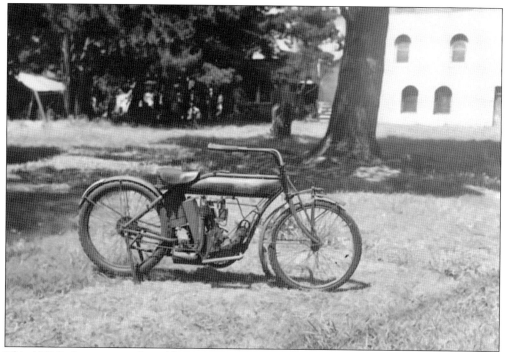

This 1911 Indian was purchased by Art Mullaney in the late 1930s. The 30.50-cubic-inch single-cylinder engine delivered four horsepower to the two-speed transmission. The white building in the background was the Hotel Neal (now the Reagan Ranch Center) at 217 State Street. This motorcycle still belongs to the Mullaney family. (Courtesy of Tony Rios.)

When Art Mullaney purchased the old Indian, the engine was seized. In 1940, Rutledge Mills took this bike to his auto-shop class at Santa Barbara High School, disassembled and reassembled the motor, and got it to run. Mills is captured here in front of Mullaney's shop on that very motorcycle. Around five years before this picture was taken, Mills made his debut at Pershing Park, racing bicycles during intermission. (Courtesy of Maureen Mullaney Hamson.)

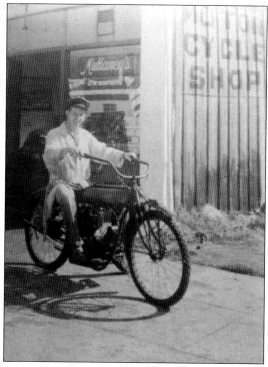

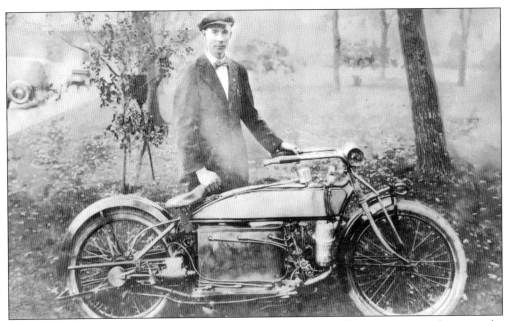

In 1922, Caleb Earl "Bud" Langford had completed the prototype of his steam-powered motorcycle. The steam cylinder connecting rod tied directly to the rear wheel hub, eliminating the need for a clutch, transmission, or drive chain. His unique motorcycle would sprint to 60 miles per hour in 174 feet and then cruise at 35 miles per gallon of kerosene. (Courtesy of Effie Langford McDermott.)

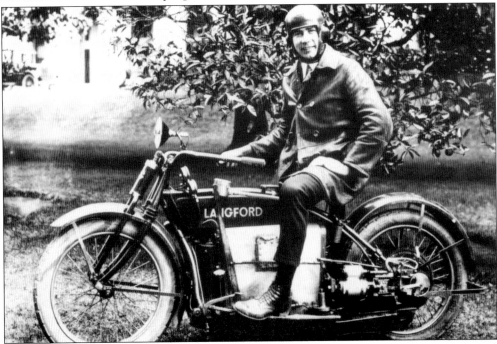

This may have been Langford's last attempt at perfecting his two-wheel steamer. He is captured here around 1930 on a shorter-wheelbase version that would have been more practical and maneuverable. Sadly, the magnificent steam machine never made it into production, and the whereabouts of his prototypes are unknown. (Courtesy of Effie Langford McDermott.)

Two
THE COURSES

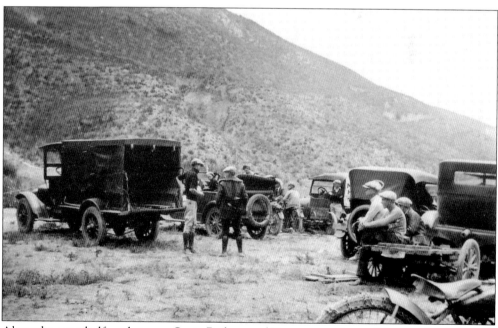

Along the coast halfway between Santa Barbara and Ventura stood one of the very first hill climb courses in the area. La Conchita (the little shell) was perfect for the sport and became a popular place for motorcycle enthusiasts to gather. Note the chain on the rear tire of the motorcycle that would become known as Class-A in hill climbing. (Courtesy of SBMC.)

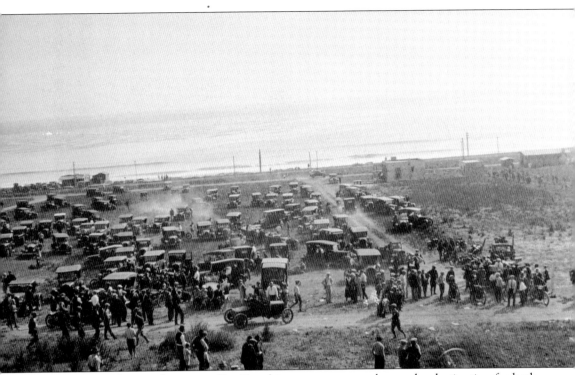

In the 1920s, the seaside venue of La Conchita was an extremely popular destination for both competitors and spectators. At the lower right is the starting line for one of the hill climb courses, and riders can be seen preparing to accept the challenge and see if they too can conquer the hill. In the center foreground, a fenderless roadster can be seen heading west on what is now Vista Del Rincon Drive. It has been said that hill climb events for automobiles were also held at La Conchita, so this roadster may well be a contestant. The tiny hamlet of La Conchita (formerly known as Punta Gorda) would remain a handful of beach shacks until it began to fill with vacation cottages and trailers during the postwar era. (Courtesy of SBMC.)

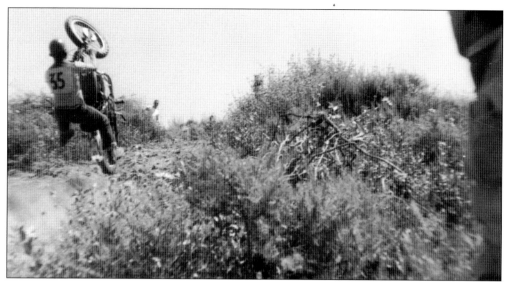

On April 27, 1958, Elmer Black prepares to part company with his Triumph Speed Twin hillclimber at the Sunday event in La Conchita. Black dominated both open and lightweight classes, making the hill in just 6.2 seconds in the open division. Bob Batastini won the lightweight scrambles, Mike McDonough placed second, and Frank Domingues came in third. (Courtesy of Phyllis Black.)

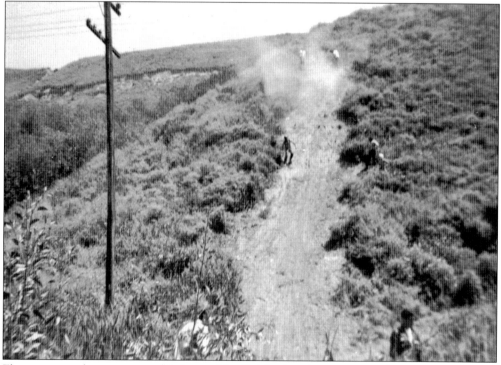

Elmer seems to have gotten to his feet and is all right, but this new course has proven to be very tricky. Some other competitors who came to test the their skills on the untried climb were George Snow, Dick Brownfield, Tom Bray, Chuck Hugo, Billy Saunders, Darwin Acres, Jack Moore, Bill McDonough Jr., George Walker, and Walter Docker. (Courtesy of Phyllis Black.)

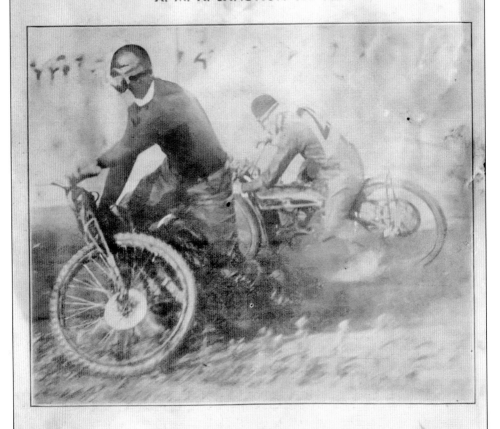

It's 1933, and short-track racing is the latest draw at Pershing Park in Santa Barbara. Lightweight motorcycles with no brakes on fifth- and sixth-mile ovals would later become known as speedway. (Courtesy of SBMC.)

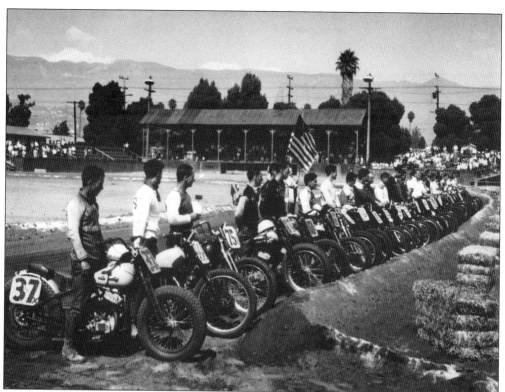

Charles "Chuck" Basney, No. 37, was first in line to stand at attention for the national anthem at Santa Barbara's Pershing Park. The berm and hay bales were there to protect the fans as the pack of motorcycles came out of the back turn, often out of control. The Pershing Park baseball diamond and parking lot now occupy this space. (Courtesy of SBMC.)

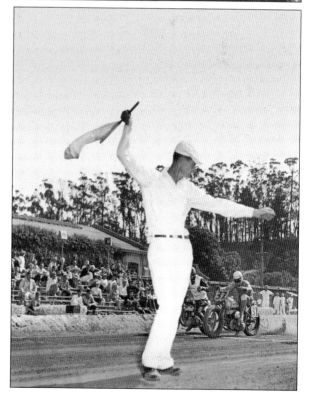

The flag waves and a rooster tail suddenly appears behind No. 37, Chuck Basney's motorcycle, as Clarence Langlo starts the flat-track races at Pershing Park Stadium in Santa Barbara. These events were sponsored by the California Highway Patrol, with 40 percent of the proceeds going to the City of Santa Barbara and 60 percent to the Santa Barbara Motorcycle Club, the profits going to benefit widows and orphans. (Courtesy of Ed Langlo.)

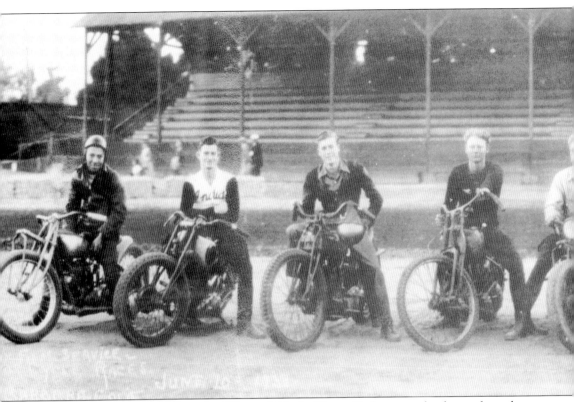

In the 1930s, Pershing Park in the "Channel City" of Santa Barbara saw the dawn of speedway-style racing. The seaside park at the corner of Cabrillo Boulevard and Castillo Street continued to draw overflow crowds for many years to come. The fifth-mile flat-track would entice world-class riders like Floyd Emde from San Diego, Ed Kretz from Monterey Park, and Ben Campanale of Pomona, California. In the lineup of this photograph taken in 1938 are, from left to right, Ace

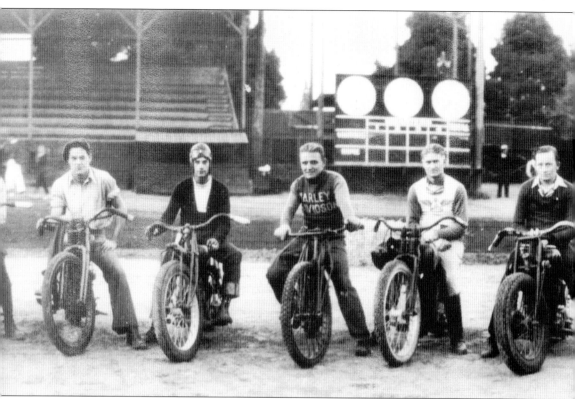

Cordero, Dick Rennie, Harry Smith, Emilio Taglepietra, Bob Davis, Jimmie Lee, Frank Brody, Walter Docker, Bill Hughes, and Pint Waddell. Nineteen-year-old Walter Docker sits on a Harley-Davidson belonging to Arther Mullaney of Mullaney's Motorcycle Shop on Montecito Street in Santa Bargbara. This bike was custom built for speedway by Mullaney from a lightweight frame fitted with a 30.50-cubic-inch F-head single-cylinder engine.(Courtesy of SBMC.)

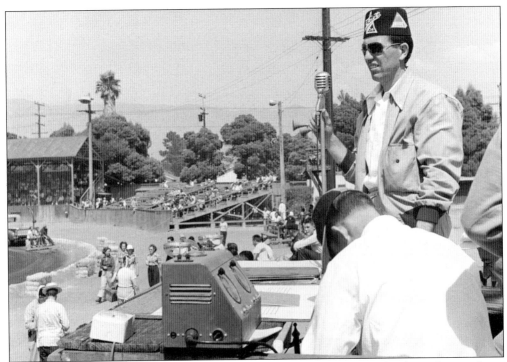

It's Sunday morning at Pershing Park in Santa Barbara. The sun is out, the sky is clear, and it is time to go racing. Attendees can smell the castor oil in the air and hear a couple of race bikes tuning up in the background. The PA system crackles to life, and Bob Mullaney announces: "It's time for the first heat race of the day." (Courtesy of Marsha Mullaney Novak.)

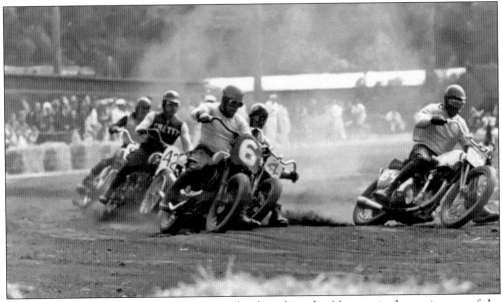

No. 64 Jack Bailey, from Eagle Rock, opens the throttle on his Norton single coming out of the turn at Pershing Park and pulls out of the pack. He is closely followed by one of the best in the nation, No. 6, Dick Milligan, out of Glendale, California. Following in the pursuit are No. 4, Louie Camou, and Earl "Smitty" Smith on No. 42. (Courtesy of Putty Mills.)

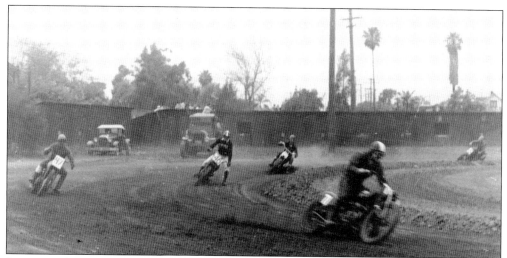

It appears that No. 11, Kelly Meyers of Los Angeles, is leading as they come through the turn at Pershing Park, followed by No. 47, Sid Wagner, and No. 46, Chuck Morris. Referee Clarence Langlo's Model A roadster is parked next to the Santa Barbara Motorcycle Club's water truck. (Courtesy of SBMC.)

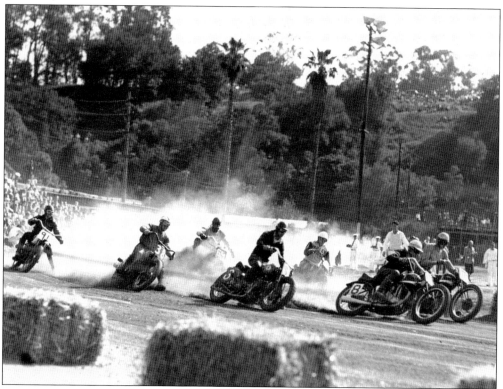

The word was out that Daytona record-holder Floyd Emde would be in Santa Barbara to challenge all comers at flat-track racing. Pershing Park is sold out and the hill above is dotted with spectators as Emde's new Ariel is in a confrontation with another Ariel motorcycle for the lead. Behind them, AMA referee Clarence Langlo (in white) can be seen keeping an eye on the action. (Courtesy of Bob Mullaney.)

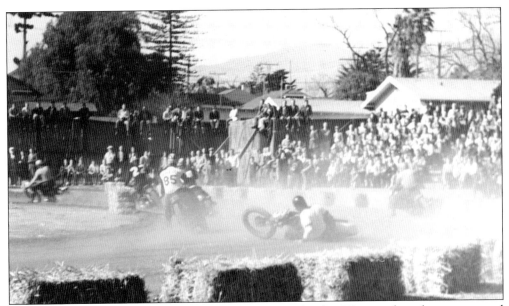

In February 1946, the stadium at Pershing Park was in its heyday. The seaside park was renowned statewide for its flat-track racing events. The popularity is evident from the number of spectators occupying the bleachers and sidelines, including the fence. No. 85, Chuck Burness of Santa Monica, is maneuvering through the mayhem of dust and fallen riders. (Courtesy of Putty Mills.)

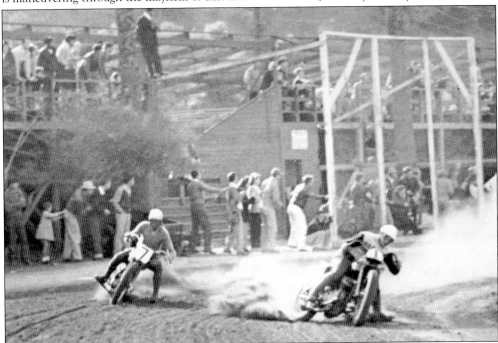

This Donnelly Studios image captured two of the most skilled riders ever to compete at Pershing Park. The number 1 was issued by the American Motorcycle Association to the reigning national champion. Ben Campanale of Pomona, California, is being challenged for first place by No. 7, Floyd Emde. It appears there is some carnage behind them. Campanale rode a Harley-Davidson, while Emde preferred Ariel. (Courtesy of Putty Mills.)

OFFICIAL PROGRAM

MOTORCYCLE RACES

SEPTEMBER 20, 1952

CARPINTERIA THUNDERBOWL

Sponsored by

SANTA BARBARA MOTORCYCLE CLUB

Price 10 Cents

In 1915, James Slaybaugh was a Harley-Davidson dealer at 21 West Ortega Street in Santa Barbara. In 1947, Slaybaugh would open the most well-remembered racecourse in Santa Barbara County, the Carpinteria Thunderbowl. (Courtesy of SBMC.)

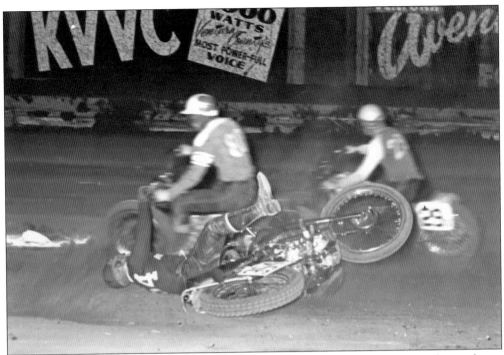

To quote Anthony Rios during a television interview: "Circumstances sometimes let you know who the fastest is." When asked to explain, Tony said, "When the rider in front of you falls down—you're the fastest!" During this event at the Thunderbowl, No. 354, Walter Docker, demonstrates how it works as No. 80, Robert Mullaney, takes the lead. Docker was okay. (Courtesy of Walter Docker.)

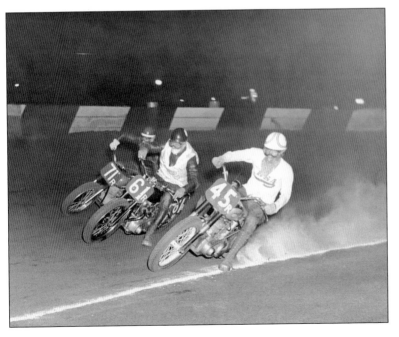

In May 1954, No. 45, Howard Mills, kicks up the lime as he slides under two other riders to make it three wide in the turn. Mills campaigned a 1950 500-cc BSA (Birmingham Small Arms) Gold Star before switching to and dominating the 125-cc class the following year at the Thunderbowl. (Courtesy of Howard Mills.)

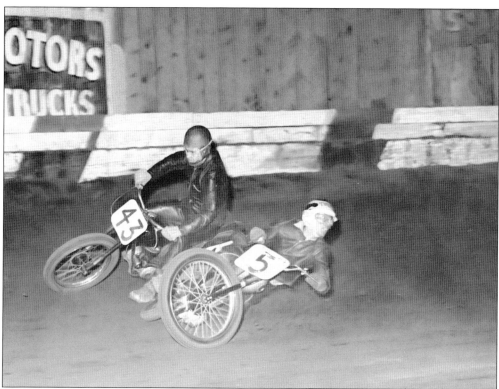

This image, taken at the Carpinteria Thunderbowl in the 1950s, depicts the outcome of a passing duel between two flat-track racers. Still gripping the handlebars, the rider on the right shows excellent style as he tries to maintain control of his bike on the way down. He is looking backwards to see who might be coming up to run over him. (Courtesy of Howard Mills.)

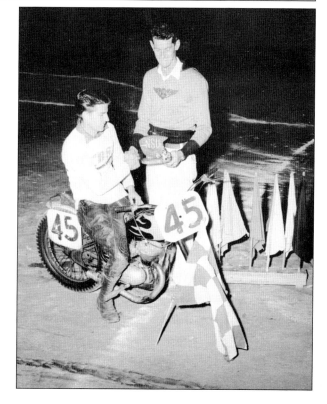

On the finish line at the famed Thunderbowl in Carpinteria, AMA referee Clarence Langlo presents the NSU (Neckarsulm) trophy to Howard Mills for his performance in the 125-cc class. Mills rode the BSA for owner Jack Smith and was the points champion for 1955. (Courtesy of Clarence Langlo.)

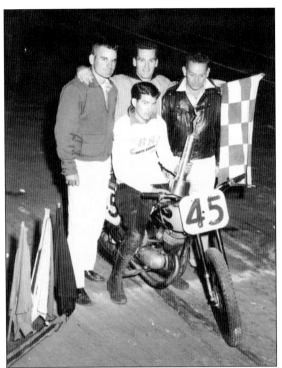

Howard Mills went home with a very big trophy as the 1955 points champion in the lightweight motorcycle division. Shown here at the Thunderbowl in Carpinteria, a young Mills sits on the 125-cc BSA he rode to the championship for owner Jack Smith. From left to right behind him are Jack Smith, Allan Campbell, and William McDonough. (Courtesy of Howard Mills.)

The proud father of rider No. 19 and sponsor of No. 45, Jack Smith poses for one more picture with the virtually identical motorcycles. Smith is holding the points trophy in his right hand and the NSU trophy presented to Howard Mills on page 49 in his left. From left to right are Willis "Bill" Smith, Jack Smith, and Mills. (Courtesy of Howard Mills.)

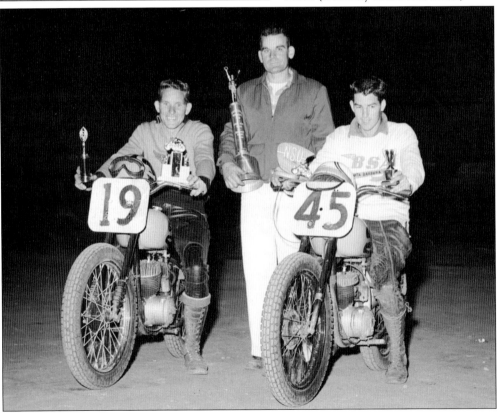

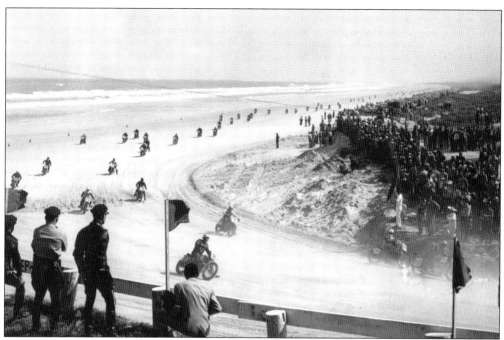

In 1951, Daytona Beach was the Super Bowl of motorcycle races, and competitors came from all over the nation for the two-day meet. All makes were represented: Harley-Davidson, Indian, BSA, AJS, Triumph, Norton—even a Rudge was entered—and they all came to win. The course was 4.2 miles on beach sand and paved roads. Sunday's 200-mile national championship race would require 48 grueling laps. (Courtesy of Marsha Mullaney Novak.)

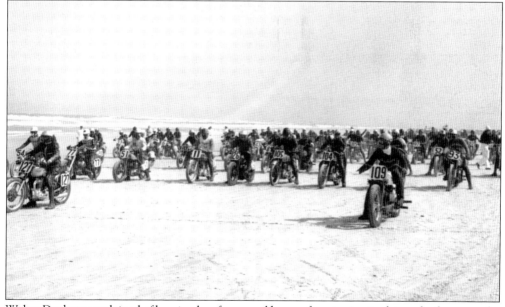

Walter Docker complained of hearing loss for several hours after starting in this pack of motorcycles at Daytona Beach. In all the excitement, he had forgotten his earplugs. These national motorcycle races, held on the sands of Daytona beginning in 1937, were the forerunners of the supercross events held there today. (Courtesy of Walter Docker.)

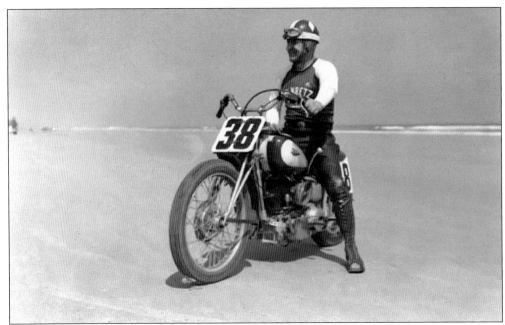

Ed "Iron Man" Kretz sits on his Indian Scout in the sand at Daytona Beach, Florida. Kretz won the inaugural Daytona 200 in 1937, which ensconced him in the record books of motorcycle racing. The No. 38 motorcycle of Kretz was often seen in competition at Pershing Park in Santa Barbara (see page 115). (Courtesy of Tony Rios.)

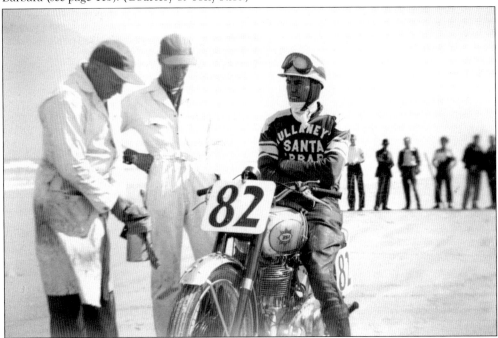

Representing the Santa Barbara Motorcycle Club in the 1951 races at Daytona Beach were Bob Mullaney, Walt Docker, and Glenn Ballard. Mullaney, seen here on his BSA Gold Star, appears to be in deep conversation with a pair of unidentified race officials about the condition of his motorcycle. (Courtesy of Marsha Mullaney Novak.)

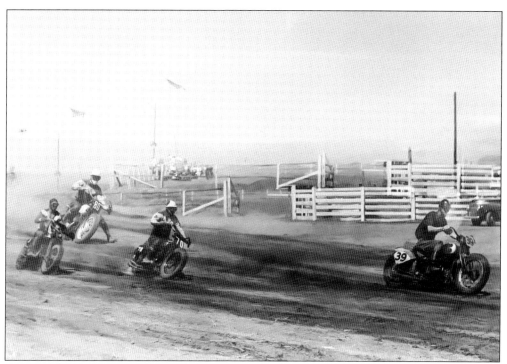

It's a windy afternoon at the rodeo grounds in Lompoc. No. 80, Bob Mullaney, from Santa Barbara, and No. 70, Ed Hearne, out of San Luis Obispo, keep the pressure on the big 80-cubic-inch Harley No. 39, ridden by Clarence Langlo, also up from Santa Barbara. (Courtesy of Marsha Mullaney Novak.)

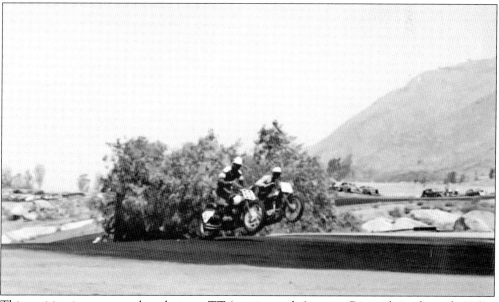

This exciting image was taken during a TT (tourist trophy) race at Riverside in the early 1950s. Bob Mullaney (left) and Tony Rios (right) get airborne as they come to the top of a curve. Note how the dirt track has been heavily oiled to eliminate the big clouds of dust that would otherwise occur. (Courtesy of Marsha Mullaney Novak.)

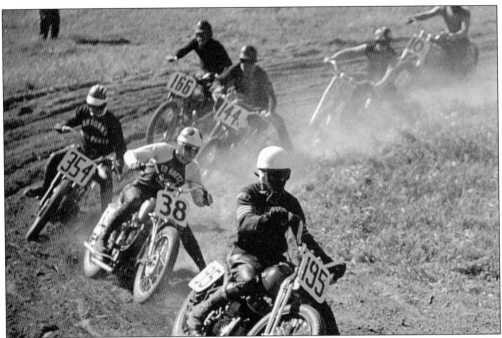

Fox Canyon was a short-lived TT course between what are today Manitou Road and Portesuello Avenue, but it saw riders like Chuck "Feets" Minert and Floyd Emde. In 1951, Ed Kretz, No. 38 (see pages 52 and 115), came to Santa Barbara to demonstrate his talent at Fox Canyon. When this picture was snapped, Ed was being closely tailed by Santa Barbara's Walt Docker, No. 354. (Courtesy of K.C. Kenzel.)

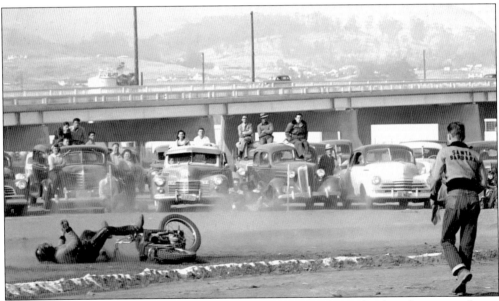

In a 1950 race, Walter Docker has pushed his Matchless a little too hard in the turn and goes down in front of the crowd at the Lemon House track. To quote Walter: "The old man went down hard that day." But it could have been worse. Notice there is no protective fence between the spectators' cars and the racecourse. (Courtesy of Walter Docker.)

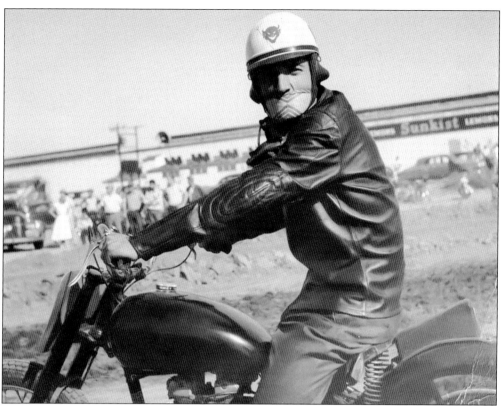

Tony Rios is seen here at the Lemon House track in Santa Barbara. The grinning devil's head and pitchfork logo visible on Tony's helmet became his trademark. Tony is also wearing a Cal-Leather competition café racer jacket. Cal-Leather jackets were worn by the Los Angeles Police Department and are still made by hand in Ventura, a tradition spanning over 70 years. (Courtesy of Jeanne La Berge Rios.)

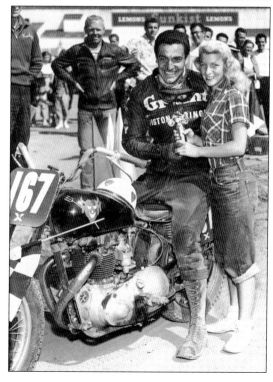

The top qualifiers in the 1953 Semana Nautica event at the Lemon House track were John Gale, Doc Watson, and Tony Rios. The three went out on the track for the trophy dash to see who really was the fastest, and Rios came out on top. Here, trophy queen Yvonne Menzel presents Tony with the cup. Off Tony's right shoulder is Swede Belin, who won the semifinal and main events. (Courtesy of Jeanne La Berge Rios.)

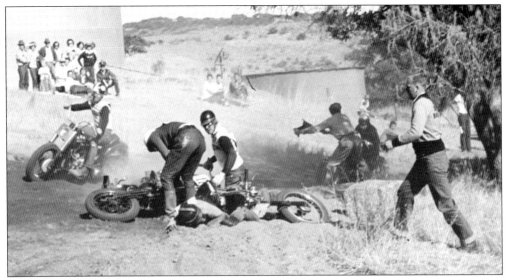

The caution flag is out as Walt Docker lies on the ground under his motorcycle at Bill McGraw's track, known as Rancho Nogot. Tommy Lark of Tucson, Arizona, captured the mayhem in 1949 as one of the Osinga brothers rushes to Docker's aid. Under this image, Walt wrote, "I've seen better moments." (Courtesy of K.C. Kenzel.)

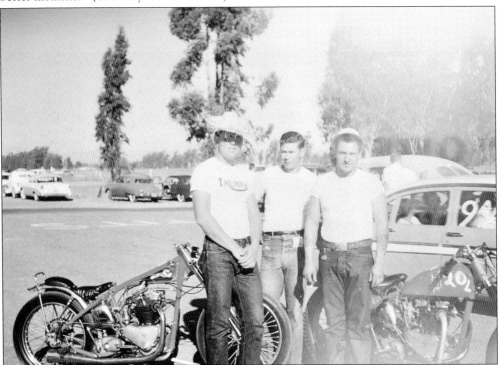

The Santa Barbara Motorcycle Club was well represented at the Santa Maria Drag Strip in the late 1950s by these three. From left to right are Laurie Scott, Elmer "Bud" Black, and Tony Rios. The Triumph on the left belonged to Black and set records with both Laurie and Elmer at the helm. Black was known for his over-the-top style, like running nitromethane and making a 115.38-mile-per-hour pass. (Courtesy of Phyllis Black.)

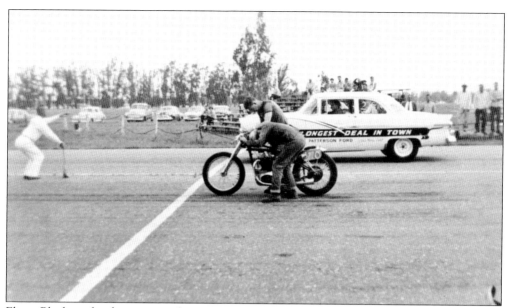

Elmer Black readies his motorcycle to go up against the Patterson Ford Fairlane at Santa Maria Drag Strip. The Y-block-powered 1956 Ford, tuned by Bob Joehnck of Santa Barbara, had just set a B gas sedan record of 104.04 miles per hour. Elmer took home first place honors in the 30.50-cubic-inch motorcycle class with a 99.44 mile-per-hour pass. (Courtesy of Phyllis Black.)

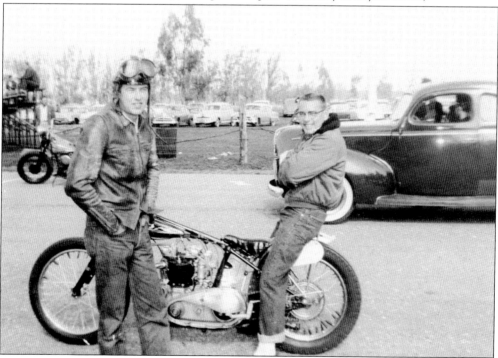

The drag strip at Santa Maria hosted races between bikes as well as hot rods. Seen here standing at left is Pete Peterson of Santa Barbara, while an unidentified enthusiast grins as he sits astride Elmer "Bud" Black's record-setting Triumph drag bike. The starting line of the historic drag strip would be just to the left of this picture. (Courtesy of Phyllis Black.)

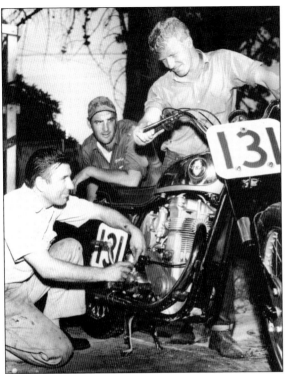

The year is 1958, and George Walker (on right) is preparing for the May 4 running of the Santa Catalina Grand Nationals (also known as the Grand Prix). The race will be contested over the famous 10-mile course through the city streets of Avalon. The BSA 500-cc single is sponsored by the Batastini brothers of Santa Barbara. This year's pit crew is, from left to right, Robert Mullaney and Bob Batastini. (Courtesy of Marsha Mullaney Novak.)

Bob Mullaney stands for a picture with Elmer Black's modified Triumph, set up for drag racing. In front is a factory-built 1959 BSA Catalina Scrambler, so named after Chuck "Feets" Minert's 1956 victory at the Catalina Grand Prix. Minert had customized his BSA Gold Star with a five-gallon fuel tank, a 19-inch front wheel, and an air-cooled brake, and BSA followed suit. (Courtesy of Phyllis Black.)

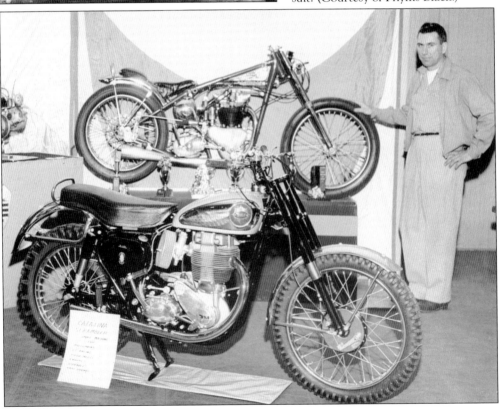

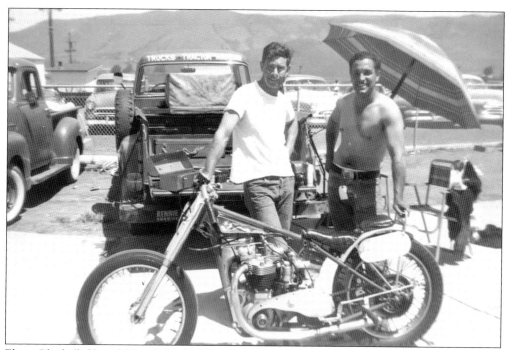

Elmer Black (left) and Tony Rios (right) are standing behind Black's Triumph drag-race bike at what appears to be the Santa Barbara Airport. The first sanctioned drag races in the nation were held at the Santa Barbara Airport in 1948 and ceased sometime in the early 1950s. This image was captured after that time but may have been taken during testing and tuning. (Courtesy of Phyllis Black.)

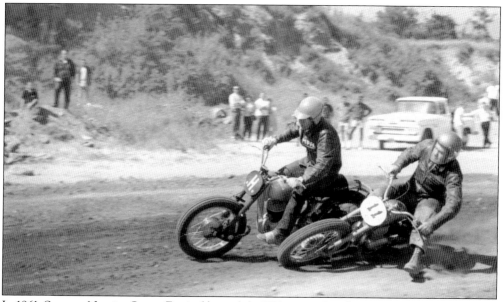

In 1961, Semana Nautica Sports Festival hosted the TT races at Leadbetter Beach before Shoreline Drive was extended down the hill. That looks like John Docker on the outside pulling ahead. The cliff in the background can still be seen below the west campus of Santa Barbara City College. (Courtesy of K.C. Kenzel.)

Veronica Springs, now known as Elings Park, was home to four separate hill climb courses. The first was on the west side of Las Positas Road, the second was in back of what is now tennis courts, the third was about three-quarters of the way up the entrance road to the park, and the fourth was an SBMC members-only practice course on the east side of the hill. (Courtesy of Ed Langlo.)

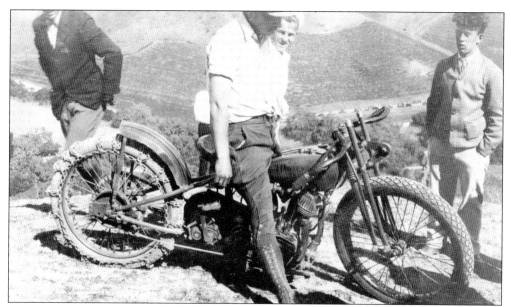

A Harley-Davidson late-model JD sits on the pinnacle of a rise known as the Big Hill, on the west side of Las Positas Road. This was the first of four hill climb courses at Veronica Springs. Las Positas can be seen in the valley below. The last year of the F-head Harley was 1929, dating this image to around that era. (Courtesy of SBMC.)

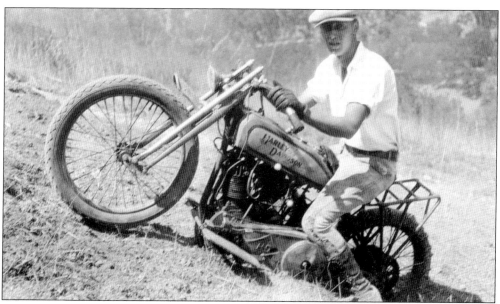

This unidentified rider pauses for a moment as he tries to figure out how to get his Harley's rear wheel out of a hole. The location is the original Big Hill, the west climb at Veronica Springs. Note the bobbed front fender, package rack, and chains for traction on the rear wheel of this attractive Harley-Davidson. (Courtesy of SBMC.)

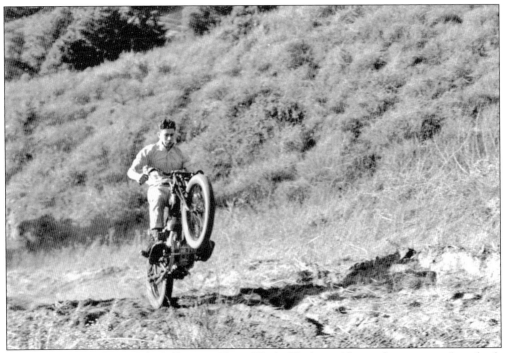

If there was ever a king of the hill, it was Elmer Black. Black would enter his motorcycle in both the standard and open traction classes and take first place in both, leaving only second-place trophies for the other competitors. Here he is in the early days topping the hill at Veronica Springs on a flathead-powered Indian Scout in his classic stance. (Courtesy of Phyllis Black.)

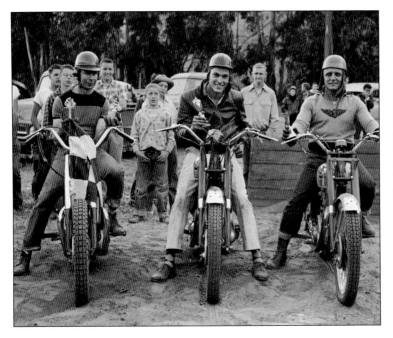

On April 3, 1955, there were 24 riders entered in the standard class and 17 in the open class at the Veronica Springs Hill Climb, and Elmer Black of Santa Barbara outgunned them all to sweep the event. Black is pictured here on the left with runners-up Jack Fennel of Ojai (center) in the open class and Walter Docker (right), also of Santa Barbara, in standard class. (Courtesy of Walter Docker.)

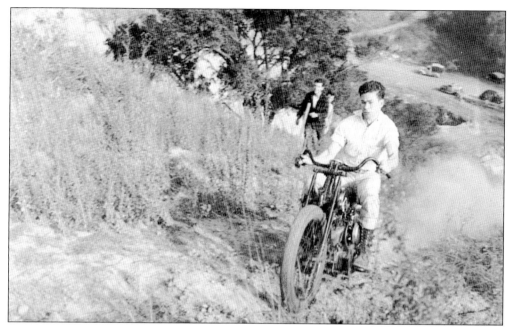

Here comes Elmer "Bud" Black over the top of the last AMA-sanctioned hill climb course that Santa Barbara would see. This was the third of three courses known as Veronica Springs on Las Positas Road. Bud looks very serious about the matter, but the smiling Bob Snow, running to keep up, is clearly enjoying the show. (Courtesy of Putty Mills.)

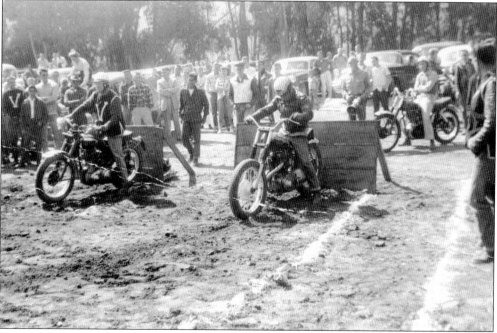

This 1957 photograph was taken at the second hill climb course at Veronica Springs, right on Las Positas Road. Paul "Paulie" Lopez is on the right against the backstop on a Triumph Tiger 100 preparing to attempt the hill in a drag race versus Harry Kile. Lopez was the last president of the original Santa Barbara Motorcycle Club in 1961. (Courtesy of Paul Lopez.)

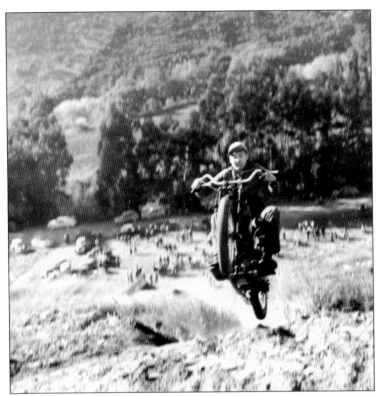

Bob Osinga is in complete control and showing excellent form as he grabs a little air coming up over the top of the east hill climb at the former dump site of Veronica Springs, now known as Elings Park. In this 1950 image, the road visible in the center background is Las Positas. (Courtesy of K.C. Kenzel.)

Tony Rios looks like he might be in trouble as he scrambles up the third and final course established at Veronica Springs. Las Positas Road is visible in the background. Tony is riding a pre-unit, rigid-frame Triumph 650 Bonneville, and his devil's head logo can be seen on the bike's gas tank. (Courtesy of Jeanne La Berge Rios.)

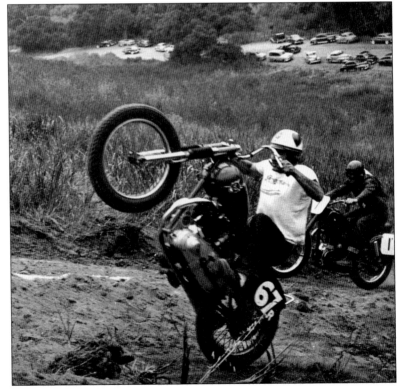

Three
THE SHOPS

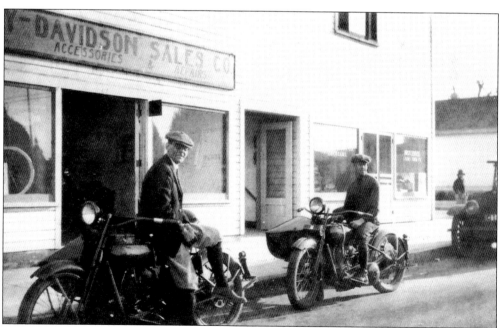

In 1915, James Slaybaugh (who would later open the Thunderbowl in Carpinteria) operated a Harley-Davidson dealership at 21 West Ortega Street. Captured in this image, Samuel Holmberg (right) and a rider listed only as Burkhart (left) are posing in front of the Harley-Davidson Sales Company at 102 East Haley Street. Sam and John C. Holmberg opened this dealership in 1925 while both resided at the YMCA on Carrillo Street. (Courtesy of SBMC.)

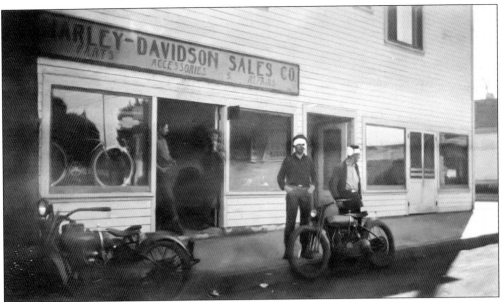

It was a solemn day in 1926 at the corner of East Haley and Anacapa Streets. Two of the club members have been involved in a motorcycle misadventure. From left to right are Fory Ames and Sam Holmberg in the doorway, Bob Zegers, and an unidentified casualty. The shiplap-sided building can still be seen today looking much the same as it did just before the Great Depression. Note the Harley bicycle in the window. (Courtesy of SBMC.)

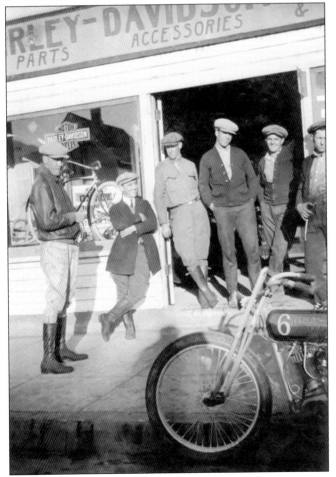

The smell of castor oil pervades the air in front of the Harley-Davidson Sales Company, the new gathering place for the Santa Barbara Motorcycle Club formed in 1924. This image, along with many of the very early photographs, was borrowed from the original Santa Barbara Motorcycle Club photo album. (Courtesy of SBMC.)

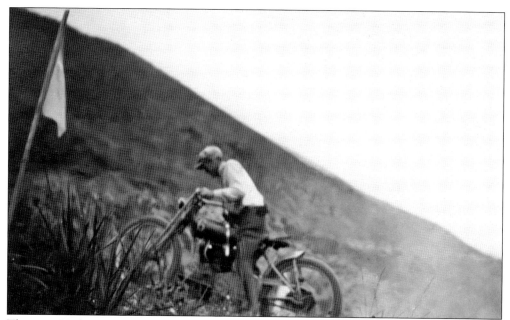

The same Harley-Davidson from the previous scene on Haley Street is caught in this action image conquering the least-known motorcycle hill climb course in the Santa Barbara area. La Conchita is a sleepy seaside community, cast into the headlines by a devastating landslide in 2005 but little remembered as a venue for competitive motorcycling. (Courtesy of SBMC.)

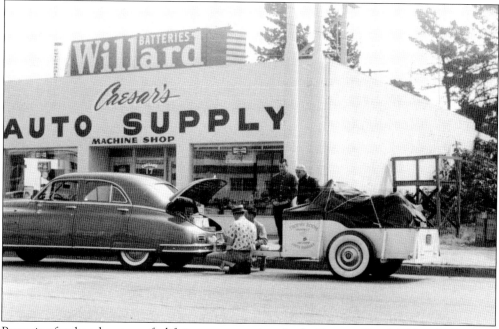

Preparing for the adventure of a lifetime as competitors in the Daytona Beach 200 at the Daytona Speedway, Florida, Bob Mullaney (left) and Walt Docker (far right) check last-minute connections. Caesar's Auto Supply and machine shop, at 17 West Montecito Street, was for years the place to go for auto parts and machine work. The same building is now home to a Ducati motorcycle dealership. (Courtesy of Marsha Mullaney Novak.)

Putty Mills is staging this photograph on Roy "Pint" Waddell's Crocker in front of Hook Klein's motorcycle repair shop at 222 Helena Avenue. Mills would go on to ride this very bike professionally at speedway tracks in Los Angeles. In 1945, this location would become the home of John Gale's Harley-Davidson dealership. (Courtesy of Tony Rios.)

In the late 1930s, Herman "Hook" Klein's motorcycle shop on Helena Avenue was the place for all the young would-be riders to meet up. This image captures Bud Black in his youth doing what a kid with a motorcycle will do: spin the tire in the dirt and create a big mess. Klein would only tolerate so much. (Courtesy of Phyllis Black.)

Bud's highly modified Sport Scout is testament to his mechanical ability, but Hook does not look delighted with all the commotion. His words can almost be heard: "Son, just because you kids like to come down here and spin around in front of my shop, doesn't mean I have to like it! You know where the push broom is—now get it and clean up your mess!" (Courtesy of Phyllis Black.)

Elmer looks a little long in the face as he cleans up the spray of dirt from the street. In 1941, with the onset of World War II, Herman Klein would leave Santa Barbara for good. This building would become John Gale's Motorcycle Shop, and at the close of the war, 222 Helena Avenue would be designated as the Harley-Davidson dealership for Santa Barbara. (Courtesy of Phyllis Black.)

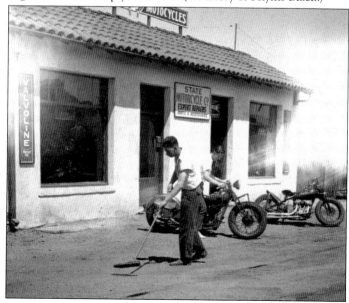

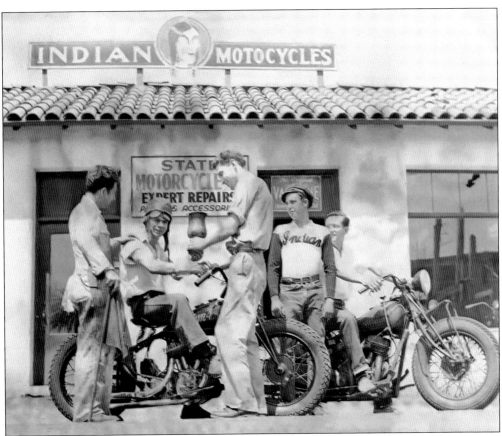

The boys gather for one last picture that day. Hook Klein (left) appears to have a makeshift flag, and Elmer Black sits proudly on his Scout as Art Stray presents him with a trophy for making the most dust around the shop. Notice the spelling "motocycle" that Indian used, in its logo on the roof. (Courtesy of Phyllis Black.)

SWEDE'S MOTOR SPORTS CENTER

Santa Barbara's Volume Motorcycle Headquarters

Featuring the sensational new Triumph, Areil and Harley Davidson — also the new SM 1500 Singer Automobile — with exclusive separate foreign car service department, for all foreign cars.

Drop in at 19 W. Gutierrez St. — Phone 7616

Swede Belin, onetime president of the Los Gauchos del Camino motorcycle club, opened his first shop at State Street and La Cumbre Road before relocating to 19 West Gutierrez Street and becoming the Harley-Davidson representative for Santa Barbara. (Courtesy of Dave Blunk.)

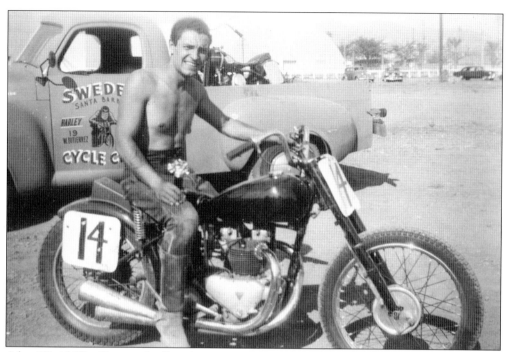

After World War II came the British invasion. Triumph and BSA dominated many of the race circuits. Tony Rios sits on his trophy-winning Triumph in front of the Swede Belin motorcycle shop's Studebaker pickup. The Gutierrez Street address on the door gives the new location; the first was on the northeast corner of State Street and La Cumbre Road. (Courtesy of Jeanne La Berge Rios.)

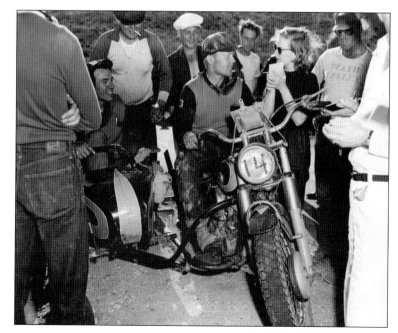

Swede Belin sits astride his ubiquitous Harley-Davidson and sidecar for an interview while his passenger, Larry Bornhurst, looks on. Belin and Bornhurst won the Greenhorn Enduro in 1950 and again in 1951. Belin traveled to Riverside in 1950 and took top honors in the 400-mile Cactus Derby with Pete Peterson in the side hack. (Courtesy of Darwin F. Acres.)

For decades, the place to go for Buick sales and service in Santa Barbara was Vincent E. Wood's, at 309–315 State Street. A three-wheeled Harley-Davidson was used to deliver parts and Buicks. The three-wheeler was equipped with a tow bar attached to the front forks that would clamp to the rear bumper of a car for the return trip. (Courtesy of Ed Langlo.)

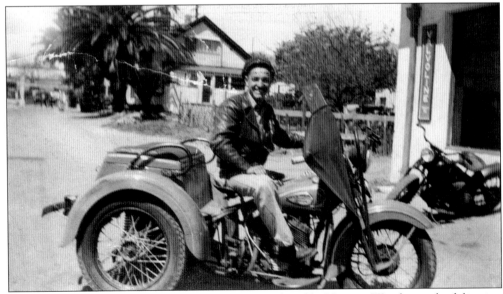

Pictured here is a young Tony Rios when he was employed by Vincent Wood to make deliveries. A close look will reveal the retracted tow bar passing by the headlight. This photograph was taken in front of State Motorcycle Company at 222 Helena Avenue. (Courtesy of Jeanne La Berge Rios.)

Francis Arthur Mullaney stands in the doorway of his Harley-Davidson dealership in this rare photograph of the "Motorcycle Shop" sign on the west side of the building. The Caesar's Auto Supply building (today a Ducati dealership) has not yet been built. In 1934, Art had moved to this location on Montecito Street from the 223 Anacapa Street shop where he had initiated his own dealership in 1931. The 1932 Ford roadster belonging to Robert Mullaney is powered by a four-cylinder model B with an Alexander overhead valve cylinder head. Young Bob Mullaney walks towards the shop. At the time of this writing, the wood-sided building still stands, and it is slated to become Mullaney's Tavern. (Both, courtesy of Marsha Mullaney Novak.)

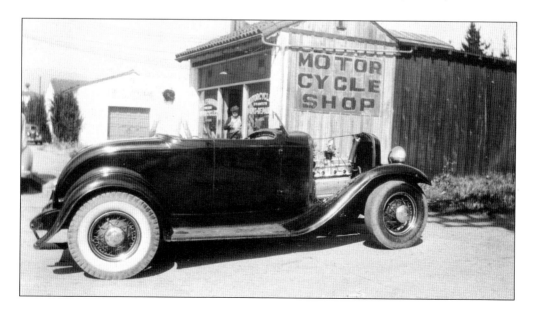

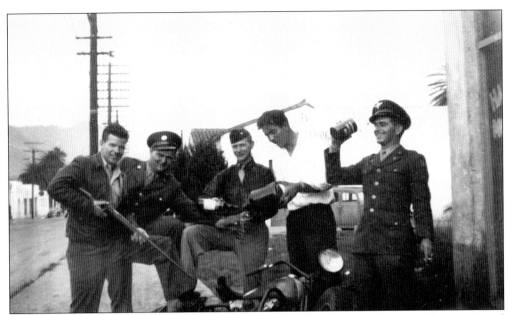

Some of the boys serving the country during World War II are home on leave and have gathered at Mullaney's for some fun. From left to right are Putty Mills, Bob Rivers, Dwight Priest, George Metson, and Rhys Price. It appears that Mills has taken the Harley-Davidson Knuckle-head as a prisoner of war. (Courtesy of Putty Mills.)

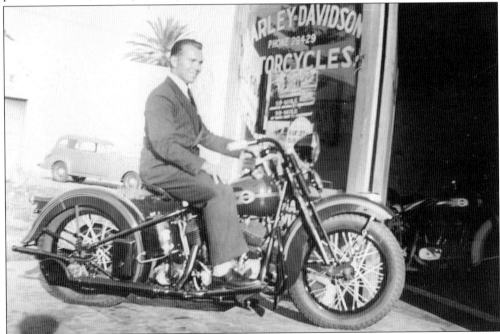

The stamp on the back of this photograph indicates that it was printed at Thrifty Drug Store in April 1939. Kenneth Mullaney sits proudly on a new Harley-Davidson VL. Born in 1908, Ken was the eldest son of Arthur Mullaney and older brother to Robert. He would answer a different calling and work outside the motorcycle industry as a sheriff's deputy in Arizona. (Courtesy of Marsha Mullaney Novak.)

The life of Francis Arthur Mullaney was a true adventure. If Harley-Davidson or Indian could not deliver it, Art would create it. The whereabouts of this half–Harley EL creation is lost to history, but this image is proof it existed. Francis's youngest son, Glenn, would be the designated aviator for this one. Glenn Mullaney tragically lost his life in an auto accident in 1956. (Courtesy of Marsha Mullaney Novak.)

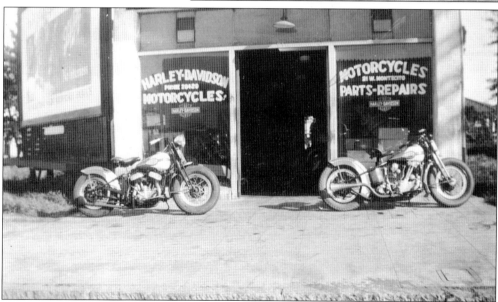

In 1940–1941, Harley-Davidson made some upgrades on both of these models. The 80-cubic-inch (1,311-cc) VLH side-valve became a ULH with aluminum heads and finned crankcase, as shown in the example on the left. The 61-cubic-inch (1,000-cc) EL knucklehead became a 74-cubic-inch (1,213-cc) FL, like Art's slightly modified single-cylinder version on the right. (Courtesy of Marsha Mullaney Novak.)

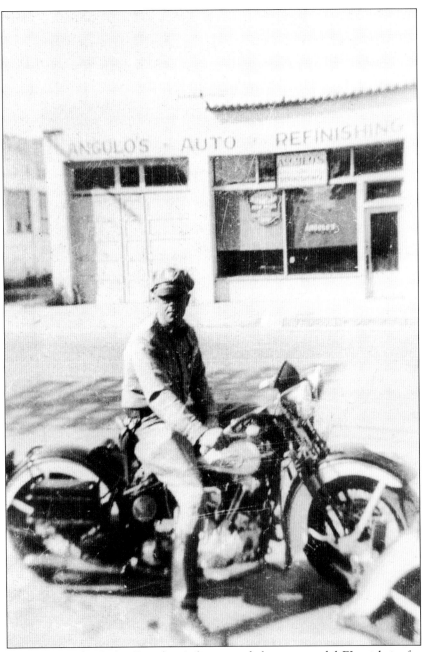

California's finest rode Harley-Davidson's finest, and the new model EL with its four-speed transmission, overhead valve configuration, and dry-sump oil system was the motorcycle of choice for law enforcement. This officer has halted in front of Mullaney's at 21 West Montecito Street, most likely for maintenance. Until 1943, Angulo's Auto Refinishing was located across the street at 22–24 West Montecito Street. If Manuel Angulo was still located there, he would be doing business in the southbound lanes of US Highway 101. The circuitous route of the highway would soon be streamlined, taking with it the north side of Montecito Street while sparing Mullaney's motorcycle shop. Angulo would relocate his body shop to 315 East Haley Street until that building was sold to George Palomarez in 1977. (Courtesy of Marsha Mullaney Novak.)

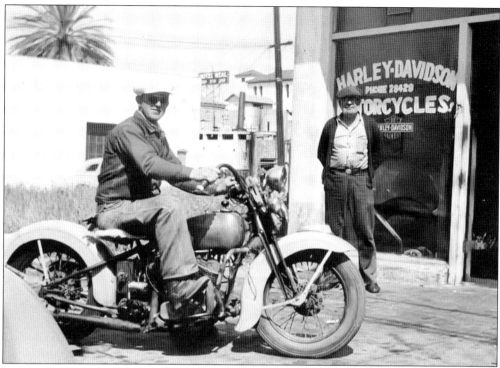

In June 1944, Arthur Mullaney stood for a photograph in front of his shop for one of the last times as a Harley-Davidson dealer. Times were changing. During the war, Harley-Davidson only produced motorcycles for the military and law enforcement. At the close of World War II, John Gale became the Harley dealer for Santa Barbara, and Mullaney turned to Indian. (Courtesy of Robert Mullaney.)

World War II has faded into the history books, and so too has the Harley-Davidson dealer at 21 West Montecito Street. Francis Arthur Mullaney would become an Indian dealer. Art is pictured in the Indian sweater, his son Robert is standing in the doorway, and the fellow in the spats was said to be a salesman. Note the two-stroke motorcycle in the window. (Courtesy of Marsha Mullaney Novak.)

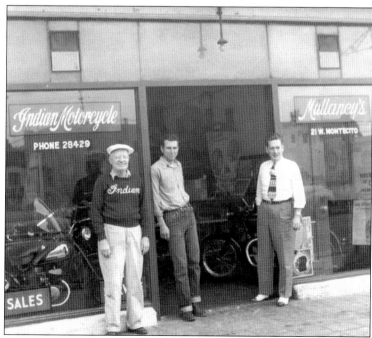

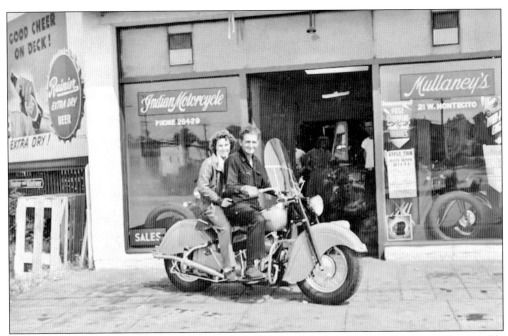

Like the billboard touts, good cheer is on deck, and the smiling couple in this image are comfortably ensconced on the dual-passenger Chum-Me seat of their new Indian motorcycle. The late-1940s Chief is found in front of Mullaney's reformed Indian dealership. Robert Mullaney is at the right side of the doorway. (Courtesy of Robert Mullaney.)

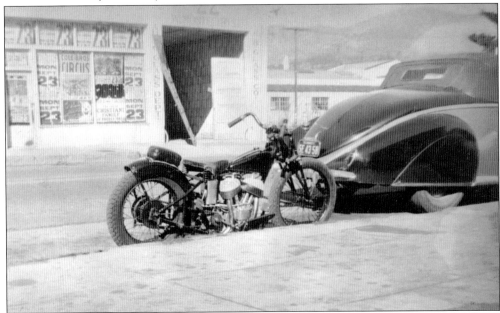

There was always something interesting parked on Montecito Street in front of Mullaney's motorcycle shop, and this day is no exception. The subject of this image is evidently the little Indian Sport Scout, but the photobomb is a Lincoln Zephyr convertible ensconced at the curb. In this 1945 photograph, 22 West Montecito Street houses Santa Barbara Glass Company shortly before it was razed to make way for Highway 101. (Courtesy of Phyllis Black.)

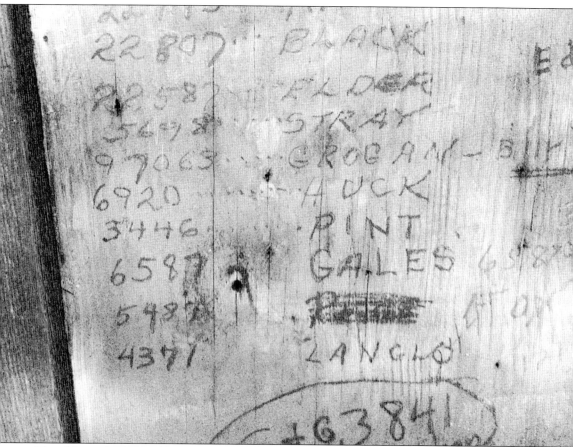

The old wood-sided building that once held Mullaney's Motorcycle Shop on Montecito Street still stands today. On visiting the old showroom during some remodel work, the author was greeted by Sheryl Schroeder, who hopes to one day open Mullaney's Tavern at that same location. Excited, Sheryl presented a section of an old wall that, when uncovered, revealed the location of a telephone and the numbers that had been written there beside it when they were still four digits. At the bottom of that list was a very familiar number from the 1950s—that of the author's father. Clarence Langlo, John Gale's Motorcycle Shop, Roy "Pint" Waddell, Henry "Huck" Kuzen, Bill Grogan, Art Stray, Lloyd "Sprouts" Elder, and Elmer "Bud" Black—the numbers are all there, as if the wall had a window into the past to see them again. (Courtesy of Sheryl Schroeder.)

In July 1960, Alan Baltes, along with his partner, Don Walters, opened his first motorcycle shop at the corner of De La Vina and Carrillo Streets. Times were hard in the beginning, and for the first three months, Al slept on a cot at the shop. Santa Barbara Motorcycle Sales was a Triumph dealer but also sold Honda, Greeves, BMW, and an occasional Rabbit scooter. (Courtesy of Al Baltes.)

In 1963, Walters sacrificed his share of the motorcycle shop to become an acoustic-ceiling contractor. Baltes persevered, moving the business to 408 Chapala Street as a Honda dealership. At the time of this writing, "Honda Al," along with his service manager, Jack Chestnutt, is still in operation at that location. (Courtesy of Al Baltes.)

Four
THE CLUBS

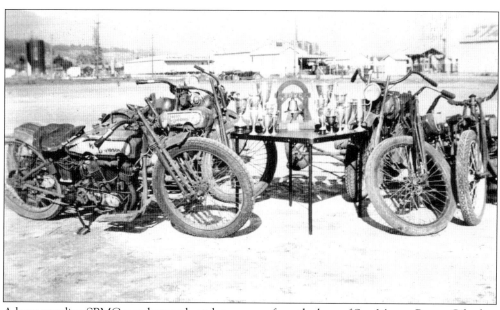

A long-standing SBMC members-only endurance run from the base of San Marcos Pass to Gibraltar Dam Campground began in 1925. This is one of the earliest images of the perpetual bell trophy. Forrest "Fory" Ames had the quickest time that first year. In the left background is the Gilmore Oil Company, located at 32 North Salsipuedes Street. (Courtesy of SBMC.)

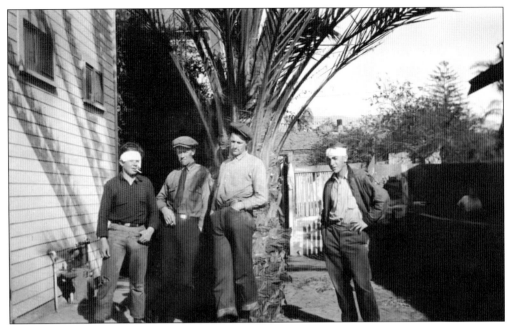

This is a rare photograph captured at the side of Holmberg's Harley-Davidson Sales Company of a group of founding fathers of the Santa Barbara Motorcycle Club. Motorcycle racing has never been without its dangers, but in 1925, helmets were not often seen. From left to right are Bob Zegers, Sam Holmberg, Fory Ames, and an unidentified victim. (Courtesy of SBMC.)

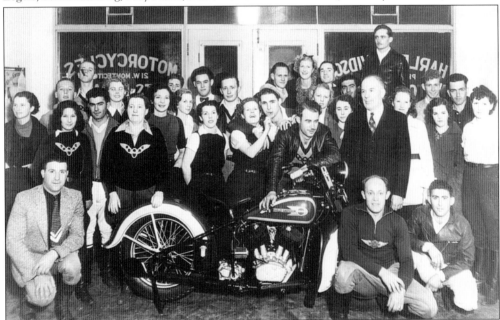

It is 1935, in the midst of the Great Depression, but it is Christmas, and there is a brand-new 1936 eighty-cubic-inch Harley in the showroom at Mullaney's. The Santa Barbara Motorcycle Club is throwing a Christmas party, and the gang has decided to pose around the first 80-cubic-inch Harley in town. Francis Arthur Mullaney is standing behind the front wheel of the prize bike. (Courtesy of Robert Mullaney.)

In 1924, a group of Harley-Davidson and Indian motorcycle enthusiasts formed the Santa Barbara Motorcycle Club. These are the cover and first page of a 15-page booklet of by-laws printed at the close of World War II and the resumption of club activities. Shown on page 1 is the club's charter number, meaning it was only the 35th club in the nation to be sanctioned and recognized by the American Motorcycle Association (now known as the American Motorcyclist Association, or AMA). The club organized race events all around Santa Barbara County. In the year 2000, the alumni members granted the name to a younger generation that is still active, making it the longest-running motorcycle club in Santa Barbara County. (Both, courtesy of SBMC.)

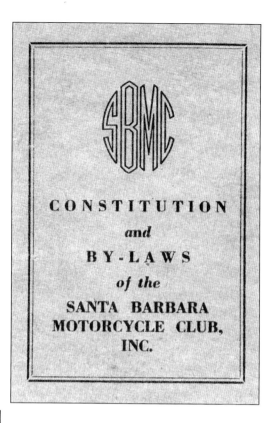

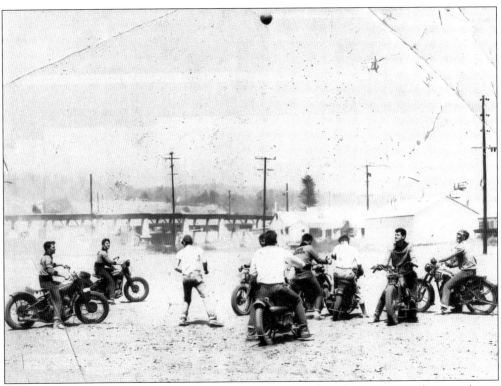

The riders are stopped, some of them looking skyward, and for good reason. They are playing motorcycle polo, and the ball is 20 feet in the air (at the top of the picture). From left to right are Donald "Bubsy" Crawford, Eddie Omera, Bob Mullaney (standing), Jim Osinga (back turned), Eddie Nau (behind Jim), an unidentified SBMC member, Putty Mills (white shirt), Clarence Langlo, and Barton Mills. (Courtesy of Putty Mills.)

The Santa Barbara Motorcycle Club held an annual members-only endurance run to Gibraltar Dam. The event started at midnight on the first Saturday after New Year's Day. In 1939, twenty-five-year-old Clarence Langlo had his name engraved on the bell of the coveted perpetual trophy. Note the radiator-hose snorkel from the carburetor to the top of the tank for the Santa Ynez river crossings. (Courtesy of Ed Langlo.)

Members of the Santa Barbara Motorcycle Club posing with club trophies are, from left to right, Bob Mullaney, John Linker, Laurie Scott, Putty Mills, Walt Docker, and Tony Rios. The bell trophy in the center was a perpetual for the Gibraltar Dam Run, of which only three people would win three times. Ironically, all three are in this photograph: Mullaney, Docker and Rios. (Courtesy of Marsha Mullaney Novak.)

Tony Rios outran the rest of the Santa Barbara Motorcycle Club to Gibraltar Dam three times, and this image is of one of those times. From left to right are Tony Rios (won in 1953, 1955, and 1957), Don "Bubsy" Crawford (won in 1956), Jim Osinga, Bob Mullaney (won in 1947, 1948, and 1959), Bob Osinga, Laurie Scott (won in 1954 and 1960), and Joe Herrera. (Courtesy of Jeanne La Berge Rios.)

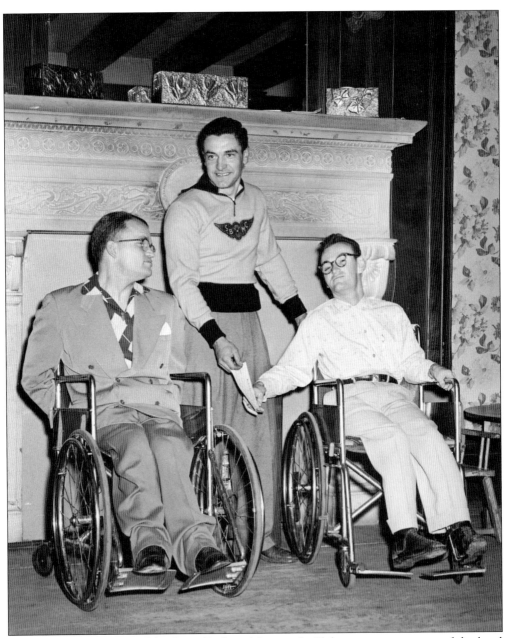

The proceeds from most of the Santa Barbara Motorcycle Club events went to one of the local charities. Hillside House, a home for handicapped children at 501 North Ontare Road in Santa Barbara, was the recipient of revenues from the hill climb events at Veronica Springs. According to early club members, those revenues were often raised by a simple passing of the hat. A young Tony Rios is shown here in 1952 presenting a check to two of the residents, Mahlon Tisdale Jr. (left) and Frank Grant (right), during their fundraising for a new facility. In 1953, Hillside House opened its new annex at 1235 Veronica Springs Road, and it is still in operation there today. (Courtesy of Jeanne La Berge Rios.)

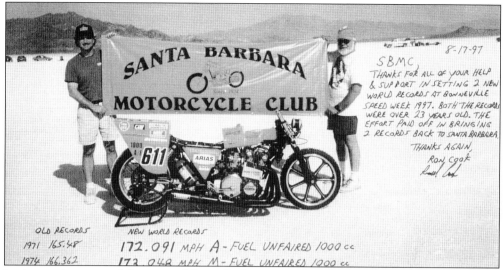

In the waning years of the original Santa Barbara Motorcycle Club, some younger competitors received sponsorship money from the club coffers to aid in their pursuits. Ron Cook was one of those competitors. Cook was able to set several records on the Bonneville Salt Flats before this motorcycle was totally destroyed in a 200-mile-per-hour mishap at El Mirage Dry Lake. (Courtesy of Tony Rios.)

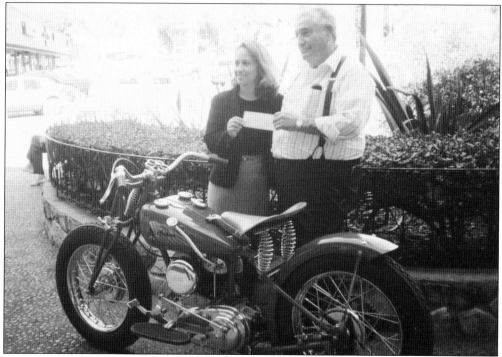

February 19, 1997, marked a paradigm shift for the Santa Barbara Motorcycle Club. The surviving members, now in their 70s and 80s, decided it was time to step down. In this image, as a last display of philanthropy, Tony Rios hands a check for $15,000, the bulk of the money left in the club account, to the Rehabilitation Institute. In 2000, the club's name was relinquished to a younger group. (Courtesy of Tony Rios.)

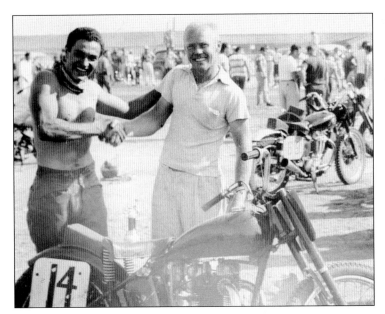

The Santa Barbara Motorcycle Club had been around since 1924 when, in 1949, a new club was formed, Los Gauchos del Camino. There was some rivalry and ill feelings between the two clubs, but in this image, Swede Belin (right), president of Los Gauchos, and Tony Rios of the SBMC are smiling and shaking hands, proof that it was not always bad blood. (Courtesy of Jeanne La Berge Rios.)

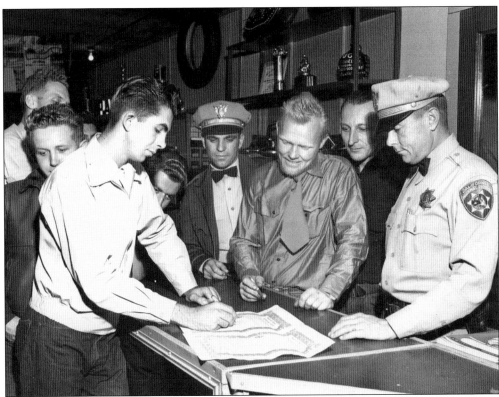

In 1949, members of Los Gauchos del Camino motorcycle club have gathered at Swede Belin's Harley-Davidson dealership to sign a safety pledge being distributed by the California Highway Patrol (CHP). From left to right are Paul Porier, signing the pledge; Charles Ferrari, of the CHP; Swede Belin, president of Los Gauchos; Ben G. Wright, secretary of Los Gauchos; and David Paul, of the CHP. (Courtesy of Dave Blunk.)

Motorcycle Riders
PLEDGE OF SAFETY
TO CALIFORNIANS

We, the undersigned, motorcycle riders and members of the <u>Los Gauchos del Camino</u> Motorcycle Club of <u>5896 Hollister Ave</u> (address) <u>Santa Barbara, California</u> (city) do hereby pledge ourselves to the safe and courteous operation of our vehicles on the streets and highways of California. We further pledge that we will endeavor to observe the following:

1. That our vehicles be equipped with a lawfull muffler at all times while operated on our streets and highways.
2. That we will keep the lighting and braking systems of our vehicles in conformity to State regulations.
3. That we will cooperate with all law enforcement agencies at all times.
4. That we will operate our vehicles in accordance with California Vehicle Code Laws.
5. That we will encourage non-club members to become affilliated with our club and become a part of our safety aims.

Accepted by and subscribed to this __27__ day of __September__, 1949.

SAVE A LIFE

GREEN CROSS FOR SAFETY

This is a scan of the original Motorcycle Riders Pledge of Safety. The signature of Paul Porier (shown on the previous page) is the 12th on this document. The boys coming home after World War II were looking for fun and action, and motorcycles were the best way to acquire both. The California Highway Patrol was there to keep them in check. (Courtesy of Dave Blunk.)

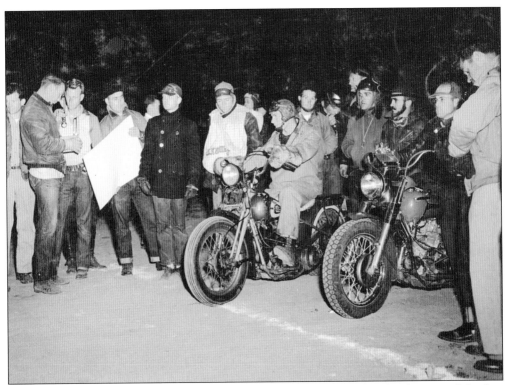

On the far left, Huck Kuzen is focused on the clock as 12:01 approaches for the start of the first Flintlock Enduro. The first competitors are Lou Mass and Bob Green. Green came in second out of more than 60 entries, and Mass finished 11th. A grueling course of over 200 miles ran up to Cuyama and back to finish at Tucker's Grove. (Courtesy of Dave Blunk.)

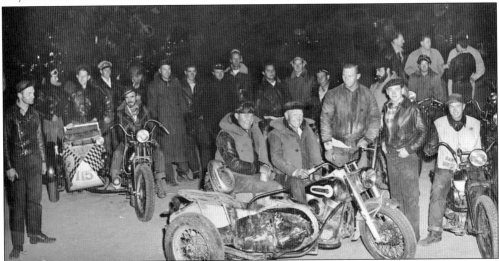

On April 30, 1950, a crowd has gathered on Leadbetter Beach for the first annual Flintlock Endurance Run, sponsored by Los Gauchos del Camino motorcycle club. The first stretch of the course is up the beach to Ellwood, so Swede Belin and his passenger, Ronnie Nirenburg, don life vests and mount a Johnson outboard motor to the sidecar. Huck Kuzen is pictured behind Belin's motorcycle. (Courtesy of Dave Blunk.)

Five
THE PEOPLE THAT MADE IT HAPPEN

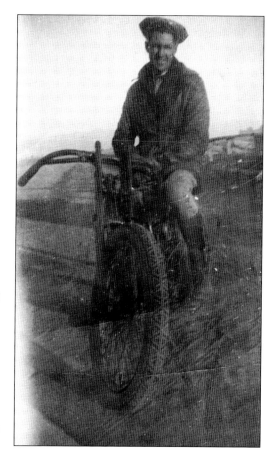

Forrest "Fory" Ames was one of the founding fathers of the Santa Barbara Motorcycle Club in 1924. In 1925, Ames would become the first to have his name engraved on the bell of the perpetual Gibraltar Dam Trophy. The Gibraltar Dam Endurance Run would carry on until 1961. This image was captured at the Santa Maria half mile in 1923. Ames posthumously contributed greatly to the known history of the club with his writings. (Courtesy of Phyllis Black.)

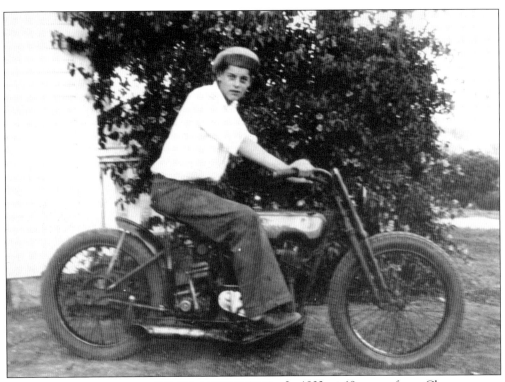

In 1932, at 18 years of age, Clarence Langlo sits for this photograph on an early-1920s Harley-Davidson model J. In less than five years, he would graduate to an 80-cubic-inch Harley VLH purchased from Mullaney's Motorcycle Shop on Montecito Street. (Courtesy of Ed Langlo.)

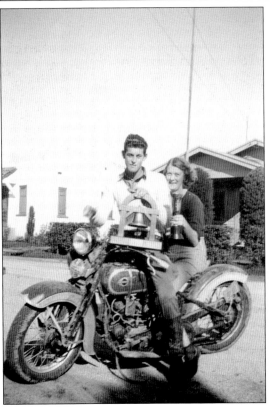

Clarence and Bernice Langlo sit for a photograph after claiming the perpetual Mission Bell and cup trophies for the 1939 Gibraltar Dam Endurance Run. At the close of World War II, the Santa Barbara Motorcycle Club, in need of a place to reorganize, used Langlo's shop, Santa Barbara Brake Service at 11 North Ontare Road, for its club meetings. (Courtesy of Ed Langlo.)

Clarence "Sundown" Langlo stands over his Harley-Davidson VLH at the Lemon House track. He would still go out on the track and compete with the modern Triumph and BSA motorcycles on the 1936 flathead-powered machine. He was almost six foot five, and the yarn was that when Langlo stands up, the sun goes down. (Courtesy of Jeanne La Berge Rios.)

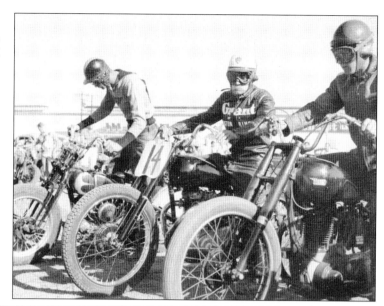

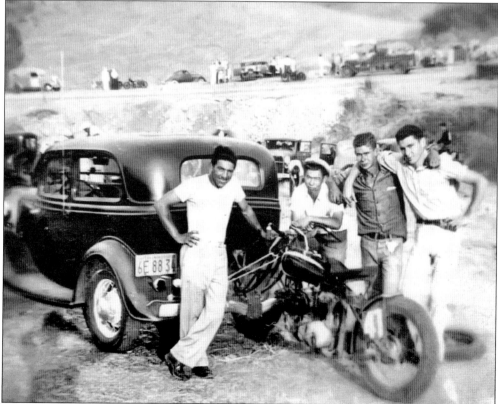

This 1934 sedan is equipped with a hitch for the front forks of a motorcycle, a convenient way of towing to the races. Clarence Langlo had such a hitch on his 1929 Ford roadster for towing his Harley VLH. While returning from the races in Lompoc, the Model A started to have engine trouble, so as "Pint" Waddell steered, Langlo fired up the Harley and pushed the roadster all the way back to Santa Barbara. (Courtesy of Phyllis Black.)

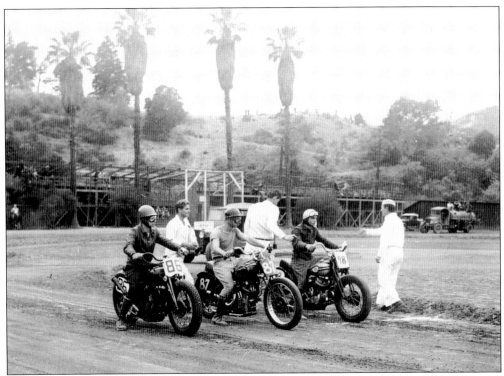

Tensions run high as the day's unrivaled competitors line up for the Trophy Dash, a contest of the three quickest qualifiers vying to see who the best really is: No. 86, Putty Mills, No. 87, Elmer Black, or No. 98, Joe Gemsa. The officials appear to be telling Gemsa to back up to straighten the line; from left to right are Rhys Price, Clarence Langlo, and an unidentified referee over whose shoulder is Langlo's Model A. (Courtesy of Phyllis Black.)

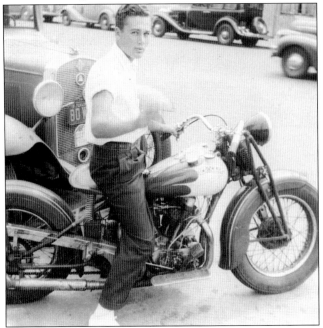

This image shows a young Allan Campbell on Don Elder's 1941 Crocker in downtown Santa Barbara. Crockers were highly regarded as some of the fastest and most well-built motorcycles on the market in their day. These bikes were not designed for dirt riding and were difficult to keep up with on a paved surface. Crocker fuel tanks (this one custom scalloped) were cast aluminum. (Courtesy of Putty Mills.)

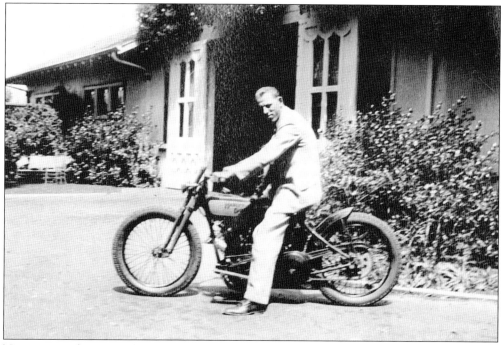

Norman Langlo captured this picture around 1929 of his friend Jim Begg sitting on what looks to be an early Harley-Davidson Model-J. They were in front of the carriage house at his place of employment. Norman worked at the much publicized Clark estate on Cabrillo Boulevard in Santa Barbara known as Bellosguardo. (Courtesy of Lorraine Langlo Hockett.)

In 1925, Norman Langlo Sr. began work as a chauffeur for Huguette Clark and her mother, Anna. This image captures Norman in a touring car, one of many vehicles owned by the Clarks. To this day, concealed in the carriage house are a 1933 Cadillac seven-passenger limousine and a 1933 Chrysler Royal Eight convertible. Both cars still display 1949 license plates. (Courtesy of Lorraine Langlo Hockett.)

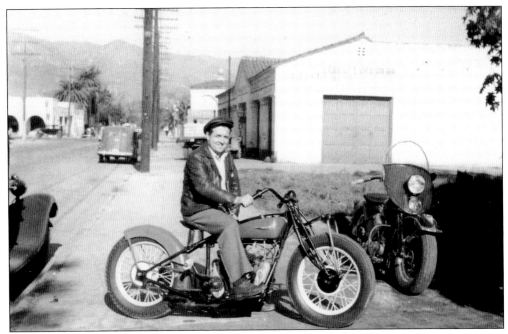

Harry Kile smiles for the camera as he poses with Tony Rios's Indian Scout on a sunny morning in downtown Santa Barbara. The location is next to Mullaney's shop on Montecito Street, with State Street crossing in the background. Most of what is visible in the background was obliterated during the decades-long expansion of Highway 101, which now runs through the area. (Courtesy of Putty Mills.)

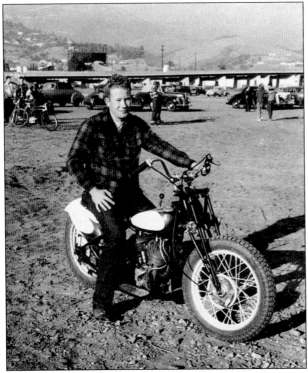

Bob Cospar, a member of the Santa Barbara Motorcycle Club, sits on a later-model Indian Sport Scout with an early Junior Scout fuel tank at the Lemon House track. The Junior Scout was often referred to as a 30-50 for its 30.50-cubic-inch displacement. The smaller tanks were popular with professional riders like Ed Kretz. Note the 1940 Ford convertible over Bob's left shoulder. (Courtesy of Putty Mills.)

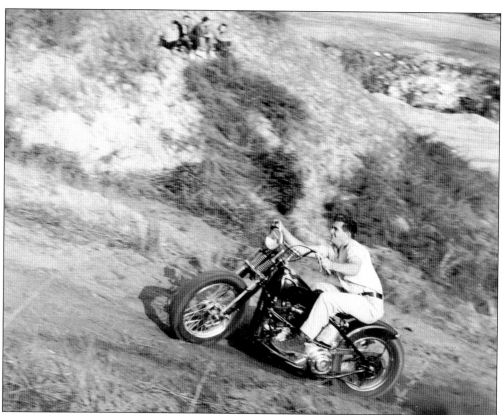

Rhys Price is making a test run at Veronica Springs wearing no helmet, no gloves or leathers, just a big grin. Price is riding what looks to be a Harley-Davidson EL, known to the boys as a knuckle-head. Harley made knuckle-heads from late 1936 until 1947. (Courtesy of Putty Mills.)

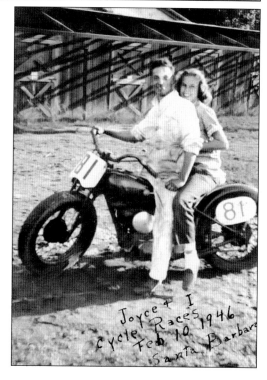

At the bottom of this picture, Tony Rios wrote, "Joyce & I cycle races Feb 10 1946 Santa Barbara." Joyce was Bob Snow's sister-in-law, Joyce Taylor. The No. 81 Indian belonged to Huck Kuzen and is listed in a February 10, 1946, program for the races at Pershing Park, with Rhys Price as the rider. (Courtesy of Tony Rios.)

97

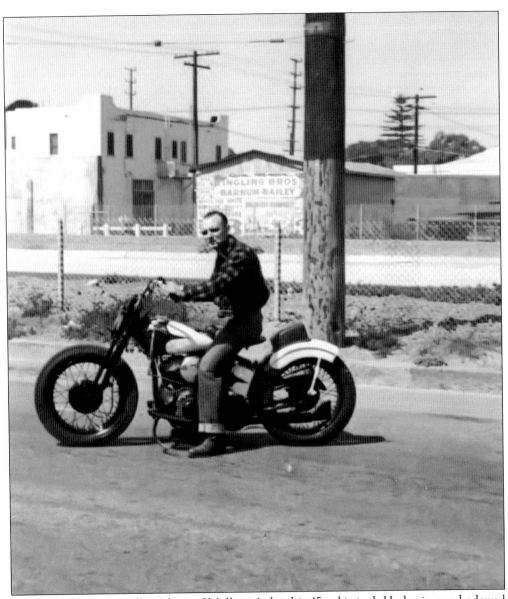

Walter Docker sits proudly in front of Mullaney's, but his 45-cubic-inch Harley is overshadowed by the backdrop. Angulo's Body Shop has succumbed to progress. That real estate is now the southbound lanes of a ghostly Highway 101, without a car in sight. There are tales from those days of riding a motorcycle all the way to Goleta and back without seeing so much as another vehicle on the unfinished roadway. The Lemon House track, also known as the Circus Grounds, would be under siege that day: over Docker's shoulder, the billboard reads "Ringling Bros. Barnum & Bailey," and the tents would be going up right on the racecourse as they had for years. (Courtesy of K.C. Kenzel.)

Members of the Santa Barbara Motorcycle Club were also productive members of the community. This image from 1970 shows Walter Docker with a wheel designed for the Apollo space program's historic lunar rover. Docker was appointed shop foreman at Delco Systems in Goleta during production of the wheels. The tires were fabricated of zinc-coated strands with titanium chevrons for treads. (Courtesy of Putty Mills.)

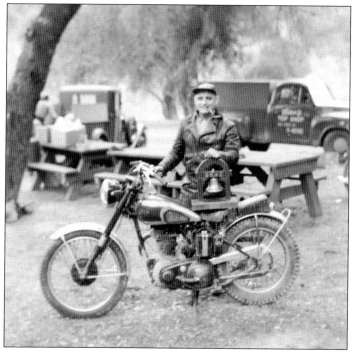

It was a rainy Saturday night in January 1952. At midnight, nine riders would leave the starting line in two-minute increments headed for Gibraltar Dam, but three of them would not make it. Of the six that did, Walter Docker would have the quickest time, making him the first person to win the endurance run three times. Art Overeem would place second and Laurie Scott third. (Courtesy of K.C. Kenzel.)

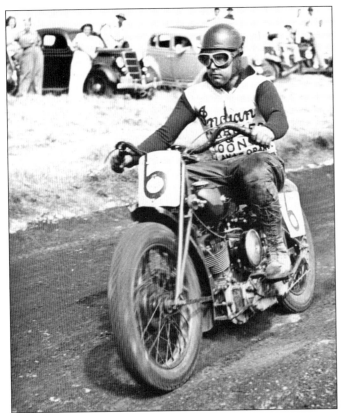

Fox Canyon, on Santa Barbara's west side between today's Portesuello Avenue and Manitou Road, was the site of TT racing in the early 1950s. It attracted racers from all over the region, like Dick Milligan of Glendale, who is seen at left astride his new-looking Indian Scout. The image below shows Milligan taking a nasty spill on the track's dirt surface. As Dick tumbles along the ground a few feet ahead of his bike, the camera has caught the Scout at an almost perfect horizontal angle to the track. (Both, courtesy of SBMC.)

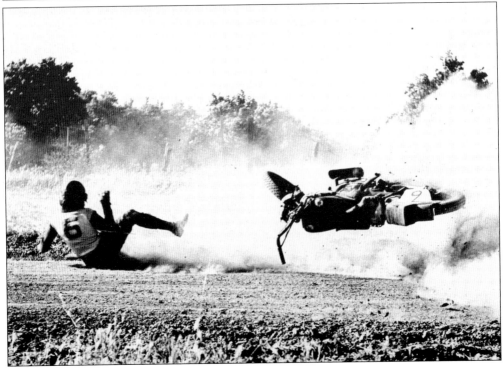

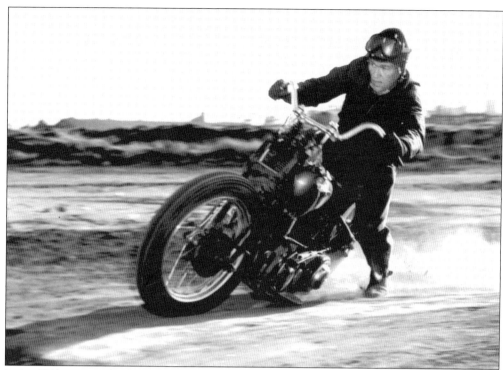

Jackie Wilson muscles his big Harley-Davidson knuckle-head into a broad slide. The E-series Harley has a pair of Flanders handlebar risers, which according to some of the boys that rode in those days made handling the bigger bikes in the dirt a little easier. (Courtesy of Putty Mills.)

During a hill climb, after parting company with their motorcycle, most riders would put as much real estate between themselves and the maverick motorcycle as possible, lest gravity encourage their own mount to come back and run over them. George Snow (Bob Snow's younger brother) had other plans, as he refuses to let go of the throttle after going over backwards and reshaping the rear fender of his bike. (Courtesy of Bob Snow.)

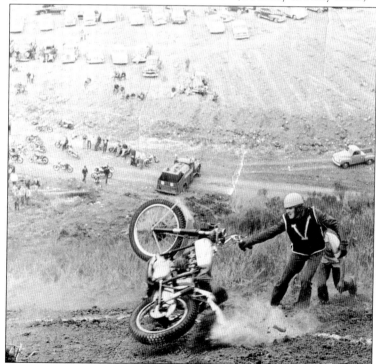

Not everyone could make it over the top of the hill at Veronica Springs in style. In this image from 1952, Evert Lower demonstrates that concept while in the process of being thrown from his motorcycle as he crests the top of the climb. Lower appears to be on the last course on the east side of Las Positas Road. (Courtesy of Walter Docker.)

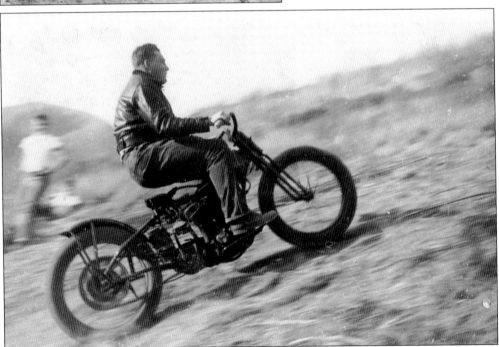

Times were different in the early days, and it was not uncommon to see a bike belonging to Putty Mills go past with someone else at the helm. In this picture snapped at Veronica Springs, big Eddie Edwards roars up the hill on Putty's Harley-Davidson. The Harley seems to pale in size under the big man. (Courtesy of Putty Mills.)

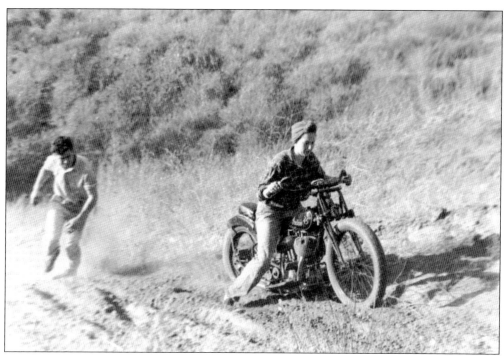

In 1951, Elmer "Bud" Black was practicing on his 45-cubic-inch Indian Scout at Veronica Springs when things took a turn. His girlfriend Phyllis Nysewander wanted to try riding the little Scout herself. Bud put her on the bike and ran alongside, holding her up, when Phyllis decided it was time to open the throttle, leaving Bud scrambling to stay on his feet. (Courtesy of Putty Mills.)

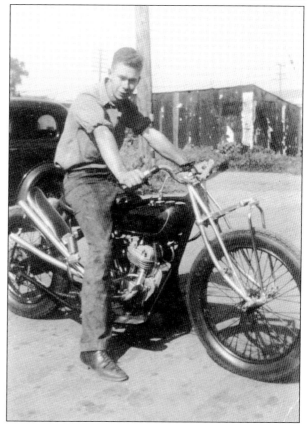

One of Elmer "Bud" Black's early creations was this 1928 Indian 101 Scout. If Bud owned it, it was a safe bet that the bike had been stroked, and this one was no exception. Sixty-one-cubic-inch Power Plus steel flywheels had been installed, resulting in 52 cubic inches. Super X connecting rods were added along with Fenwick cams and late-model Sport Scout cylinder heads. (Courtesy of Tony Rios.)

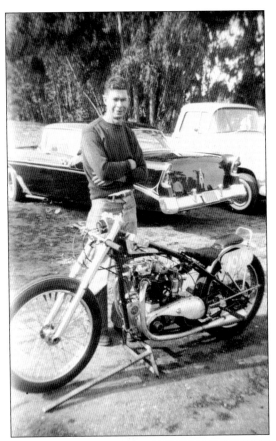

Elmer Black is seen here proudly posing with his modified Triumph 650 Bonneville drag bike. There are too many modifications visible to list here, but among them are slightly raked front forks, short handlebars, and a cut-away gear case cover. There appears to be a charging tiger painted on the tiny fuel tank, and check out that cool Chevrolet in the background. (Courtesy of Phyllis Black.)

Elmer Black caught up with the Dubble Trubble Triumph at the Santa Maria drag strip to capture this image. Multi-engine vehicles—both cars and motorcycles—were a common sight at the drag strips in the 1950s and 1960s. Santa Barbara's Arley Langlo campaigned a dragster powered by twin blown Chrysler engines at the local strips. (Courtesy of Phyllis Black.)

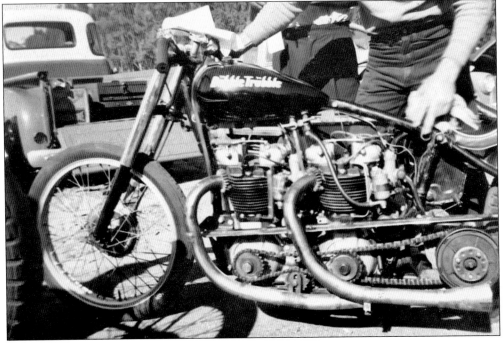

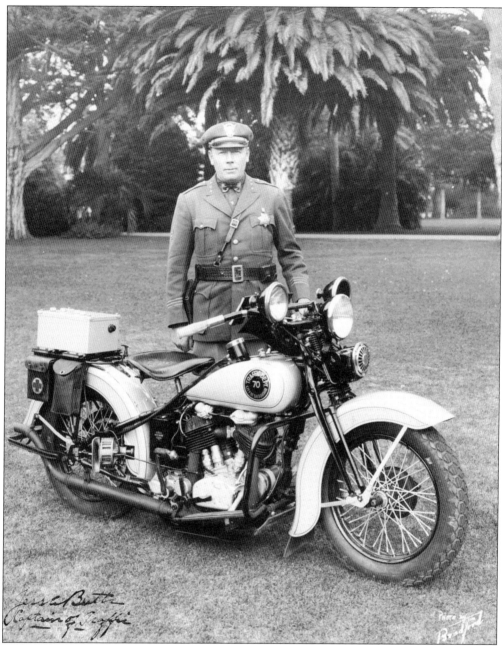

Art Mullaney maintained both California Highway Patrol and city police department motorcycles. This autographed image of Jess A. Butts, captain of traffic, was given to Mullaney out of appreciation for all his work. Captain Butts was the chief of police in 1934 and 1935. On June 7, 1935, Edmund O. Hanson, the newly elected mayor of Santa Barbara, took office with a vow to replace all city department heads. Jess Butts was one of those casualties. Only a handful of city officials would remain in office. During the 17 tumultuous months of Hanson's term in office, he himself would face a litmus test in the form of a recall election. On April 1, 1936, Mayor Hanson won by a narrow margin—6,117 to 5,143—but after a confrontation with superior court judges, on December 10, Edmund O. Hanson resigned from office for good. (Courtesy of Marsha Mullaney Novak.)

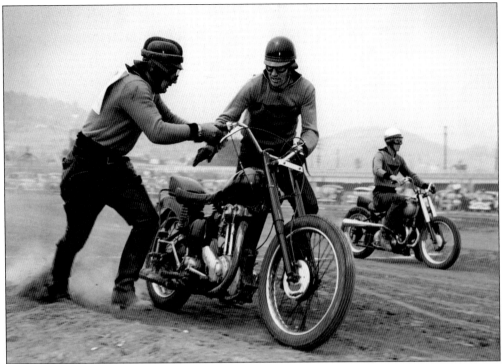

The year was 1950, and there was a relay race at the Lemon House track in Santa Barbara. Walter Docker (left) is frantically trading places with James "Jimmy" Mills, owner of the Ariel Red Hunter 500 single. To quote Mills: "we waxed them by perfecting a rider exchange technique in those relays." (Courtesy of K.C. Kenzel.)

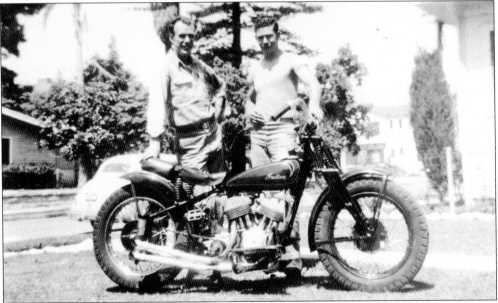

Bill "Bucks" Grogan stands behind his slick-looking Indian Sport Scout with his friend Elmer Black. The bike is outfitted with a Junior Scout tank and appears to be in race trim, as it has no lights or mufflers and does not appear to have a battery or generator. (Courtesy of Phyllis Black.)

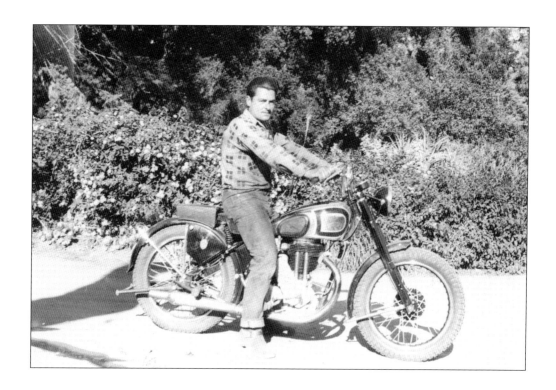

In general, times were rebounding at the close of World War II, but life was still hard for some. Louis Meraviglia (above) had lost his father, and his mother, Rosa, decided to liquidate the family's ranch. A portion of the property was isolated by Highway 154 (San Marcos Pass). Louis asked his mother for that piece of property. "I think Huck Kuzen will trade me for a Matchless motorcycle," he told her. This story was told at lunch counters around Santa Barbara for years, but at the writing of this book it was challenged. After a visit to the county recorder's office, this document was produced by Charles Meraviglia, Louis's son, and confirms that the transaction actually took place. Henry Kuzen owned the Matchless dealership at 154 and Hollister Avenue and traded the 1947 bike for a view lot. (Both, courtesy of Charles Meraviglia.)

This is one of the most unique and interesting motorcycle stories in the compilation of this book. The 1937 image above shows a home-built speedway bike known as a Peashooter, made up of mostly mid-1920s Harley-Davidson components. This motorcycle had clincher rims to hold the tires on during high-speed slides. It had no clutch, so the races would start from a roll, sometimes with a pace-bike. It had no brakes and no battery. It belonged to a 14-year-old kid by the name of Rutledge "Putty" Mills. To quote Mills: "I was down at the track one day and these two guys, Phillip [Ace] Cordero and Val Gray, were arguing over the price of this bike, and they got down to $6. I was only 14 and a little intimidated, but I had some money from mowing lawns so walked over and said, could I buy that bike for $6, and that's how I got into motorcycling. I went home with that frame and a box of parts for $6." (Courtesy of Putty Mills.)

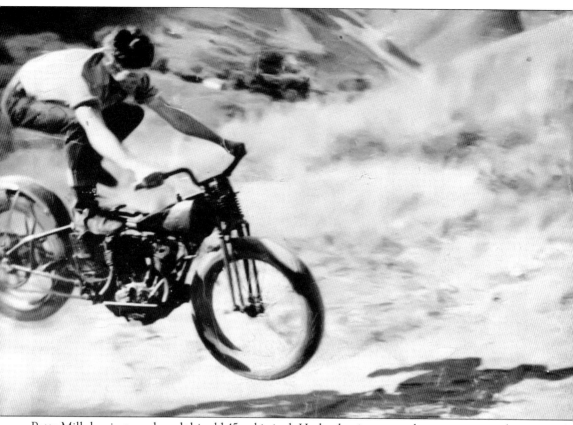

Putty Mills has just purchased this old 45-cubic-inch Harley, but it seems to have more power than he expected. To quote Mills: "This guy would bring a Harley 45 to the hill climbs and do pretty well with it. Then he would take the motor out and put a 52 inch stroker motor in it and make an exhibition run to show how fast he could climb the hill. When he passed away, I bought the bike and both motors from his widow. When Tony Rios and I took the motor out of the bike to check it out, we noticed the piston went a long way down in the cylinder, so we measured it and said; oh this is the stroker motor! But when we tore the other motor down, the piston went way down in the cylinder on it. It was a stroker too! So this guy was running a 52-inch stroked motor all along in the 45-cubic-inch class and got away with it." (Courtesy of Putty Mills.)

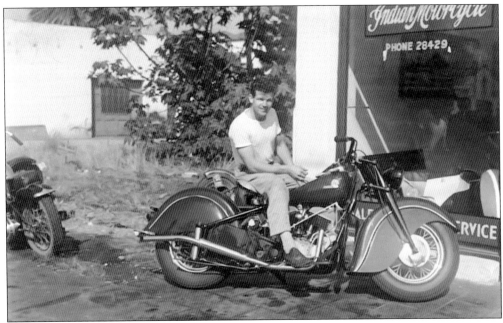

It's 1946, World War II is over, and soldiers have returned home looking for better times. Hap Alzina, the Indian distributor for the West Coast, has just delivered the first Chief to Mullaney's dealership on Montecito Street, and Rutledge "Putty" Mills has his name on it. A small group has gathered to have a look at the new 74-cubic-inch motorcycle. Quoting Mills: "We pulled the sides off the crate, added oil and gas, and warmed it up. I pulled it into first gear, lifted the clutch at full throttle, riding it straight off the pallet across the sidewalk and down the street." Putty is shown here on that very sidewalk (above) and kicking up some dirt (below) with the first postwar Indian Chief in Santa Barbara. (Both, courtesy of Putty Mills.)

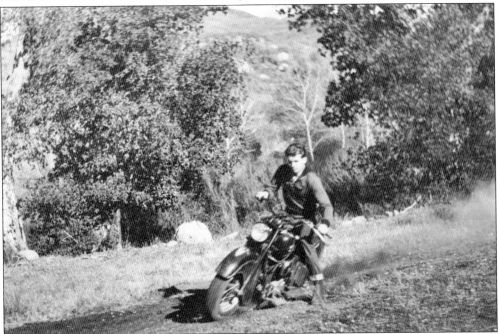

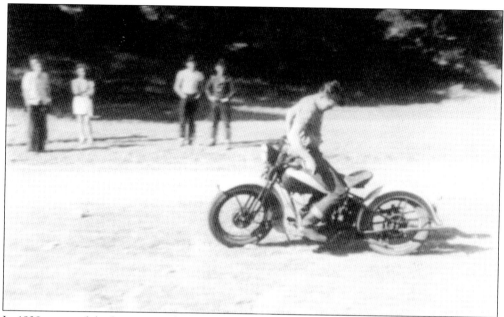

In 1938, some of the boys are at the Billiwhack Ranch in Santa Paula, California, for some fun. Putty Mills was well known for his antics, including mounting his motorcycle backward and spinning circles in the dirt. The laughter and applause of the onlookers only encouraged the practice until Putty could ride thus around the entire racetrack. (Courtesy of Putty Mills.)

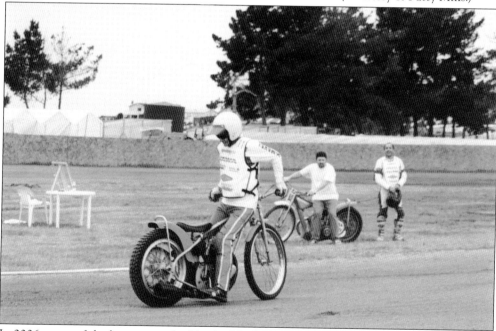

In 2006, some of the boys are at the Vander Meulen Ranch in Orcutt, California, for some fun. The onlookers are still applauding and shaking their heads as Putty Mills (now 81 years old) rides backward on his 500-cc Jawa Speedway bike. The motorcycle in this image in not equipped with brakes. Readers can see more on YouTube by searching for "Putty Rides at 90." (Courtesy of Putty Mills.)

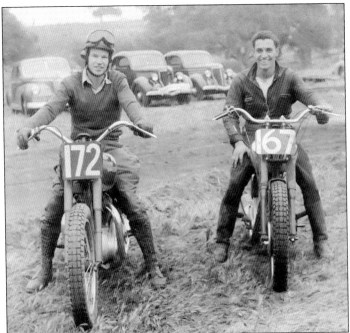

This image was captured on the Fox Canyon TT course, between modern day Portesuello Avenue and Manitou Road. On the left is Putty Mills on Glen Ballard's No. 172 Triumph, which Mills rode in competition that day. On the right, Tony Rios sits on No. 167. Car enthusiasts will appreciate the two 1936 Ford coupes in the background. (Courtesy of Jeanne La Berge Rios.)

Putty Mills was impressive at things other than riding a motorcycle. Mills almost single-handedly built the terrestrial adaptation of the lunar rover seen in this photograph. Mills held a commercial pilot's license and would fly astronauts to training grounds to instruct them at operating the rover in preparation for a moon landing. From left to right are astronauts Charles Duke and John Young of Apollo 16, along with Putty at Henderson, Nevada, in 1970. (Courtesy of Putty Mills.)

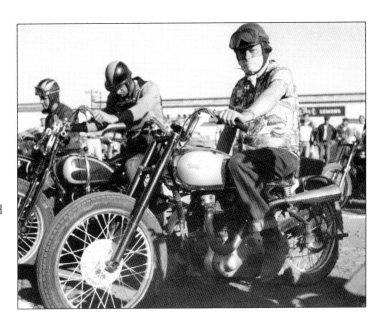

Roy "Pint" Waddell is captured here on what is said to be the first Triumph motorcycle to enter competition in the Santa Barbara area. Ironically, beside him is Clarence Langlo on the first 80-cubic-inch Harley-Davidson in Santa Barbara. Due to limited production, the 1936 Harley was acquired by Arthur Mullaney of Mullaney's Cycle Shop through a dealer's raffle in December 1935. (Courtesy of Putty Mills.)

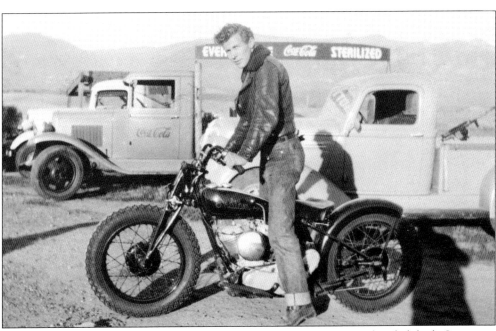

Don Elder stands proudly with his 45-cubic-inch Indian Sport Scout. This slick little Scout was built by Bud Black and was slimed down by using a 1932 Junior Scout tank. The Ford flatbed in the background is fitted with a sign advertising Coca-Cola, every bottle sterilized. (Courtesy of SBMC.)

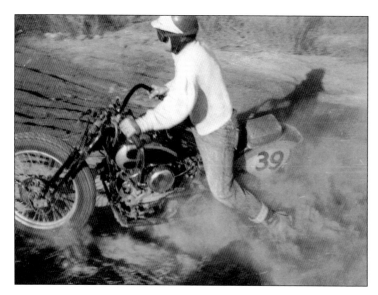

Glenn Mullaney was one of Art Mullaney's sons and the brother of Bob Mullaney. In the fall of 1948, Glen was captured in this image sliding Clarence Langlo's big 80-cubic-inch Harley through a turn. The 1936 VLH was hopped-up with a cam change and four-speed transmission and ran well, as evidenced in this picture. (Courtesy of Putty Mills.)

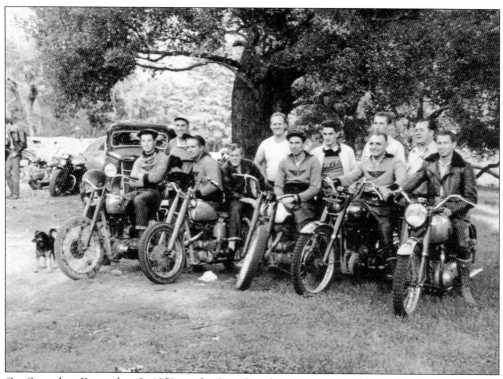

On Saturday, December 2, 1951, at the Los Gauchos Motorcycle Club's third annual turkey run, some of the boys are lined up at Tuckers Grove for a snapshot. From left to right are Eddie O'Meara, Roy Jenkins, Sonny Linker, unidentified, Bob "Swede" Nielson, "in white shirt", Bob Mullaney, unidentified, Walter Docker (on a motorcycle), Jimmy Clearwater (behind Docker), Harry Kile, and Joe "Dee Dee" la Barge. (Courtesy of K.C. Kenzel.)

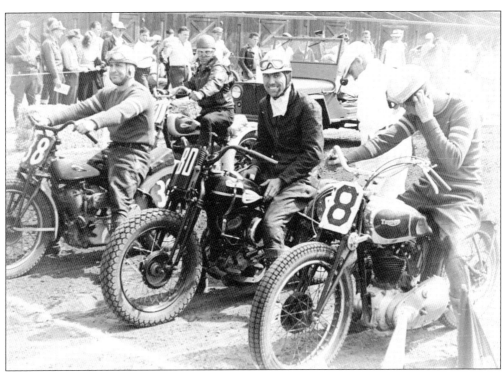

From left to right, No. 38, Ed Kretz, owned an Indian dealership on Garvey Boulevard in Monterey Park, California; No. 80, Bob Mullaney, owned a Harley-Davidson dealership in Santa Barbara; and No. 8, Bruce "Bo Bo" Pearson, on the Triumph 500 single, was a banker. The official in white studying Mullaney's rear wheel is Stan Irons, a well-known AMA starter. (Courtesy of Marsha Mullaney Novak.)

Ed "Iron Man" Kretz was no stranger to large trophies. After winning at Daytona in 1937, Kretz went on to win the Langhorne 100-mile dirt-track race and Laconia in 1938. Indian paid Ed $200 a month for campaigning his Indian Sport Scout at racetracks across the country. He was voted AMA's most popular rider in 1938 and again in 1948. (Courtesy of Tony Rios.)

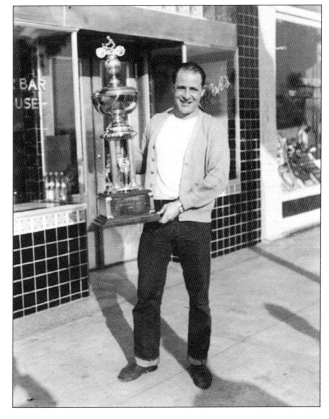

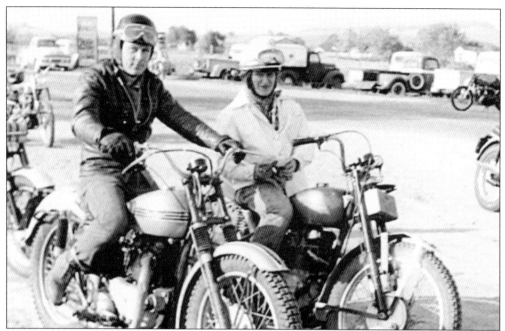

In 1957, Glen and Irish Schlagel are stopped at a checkpoint for an endurance run in Fresno, California. Irish would ride her own bike right alongside the guys. Irish Menzel Schlagel liked to be involved in any way she could, so when the SBMC members-only Gibraltar Dam run came up, she sponsored Tony Rios to ride her Triumph just to say she did. (Courtesy of Michele Schlagel Hoffman.)

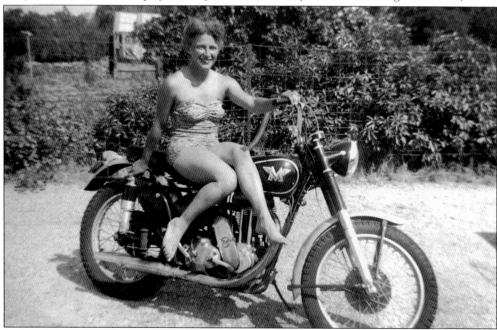

Irish was also a lady with a feminine side. Posing on this Matchless, she puts all question of that to rest. Irish stayed active and involved in motorcycle events throughout her life, and when the SBMC became the Alumni Club in 2000, she could be seen at Harry's Plaza Café for the meetings. (Courtesy of Michele Schlagel Hoffman.)

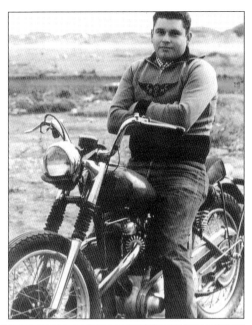

Joe Herrera, donning a Santa Barbara Motorcycle Club sweater, sits proudly on his sanitary Triumph. The distinct cup-sized bulge in the side cover houses what was known as a cushion sprocket, which generated a smoother ride at low speeds. Herrera's name first appears in the club records in 1952, placing him right in the middle of the British invasion of motorcycles. (Courtesy of Tony Rios.)

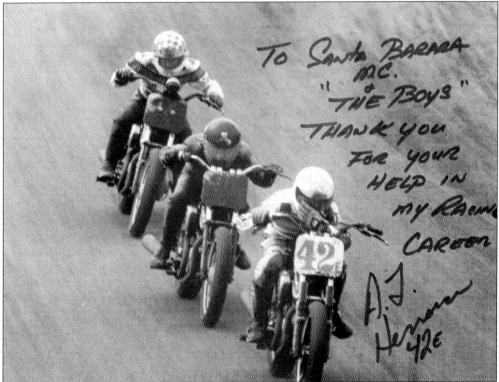

A.J. Herrera was yet another recipient of support from the Santa Barbara Motorcycle Club. This autographed picture shows A.J. in his prevalent position—out in front. A.J. was of the fourth generation of motorcycle enthusiasts. His father, Tony, was his avid supporter, his grandfather Joe (pictured at top of page) was a member of SBMC, and his great-grandfather Vincent was one of the founding fathers of the club in 1924. (Courtesy of Tony Herrera.)

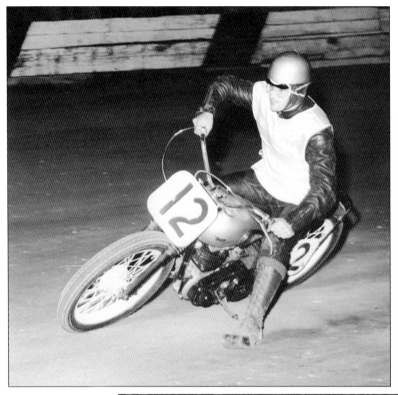

Stan Tucker rides his BSA through a turn at the Carpinteria Thunderbowl in the mid-1950s. Tucker was known as one of the fairest and most cordial competitors at the racetrack. The BSA appears to have a Keystone frame, with the engine being part of the structural support of the motorcycle. Note the steel skid-plate on Stan's left boot. (Courtesy of Howard Mills.)

Donald "Bubsy" Crawford sits on a late-model Indian 500 vertical twin with what appears to be a modified TT style exhaust. In the early 1950s, Indian was operated by Brockhouse (a British engineering firm), producing a 250-cc single and a 500-cc vertical twin with limited success. By 1953, production of the Warrior had ceased.

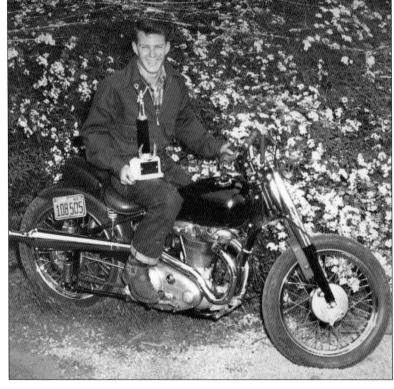

In 1948, Floyd Emde entered the 200-mile event at Daytona Beach, Florida. Not only would he win that day, but he would also complete the course in a grueling 2 hours, 22 minutes, and 48 seconds to establish a new world record of 84.01 miles per hour average over beach sand and paved roads. (Courtesy of Marsha Mullaney Novak)

The No. 172 Triumph Speed Twin, with Putty Mills at the helm, is right on Daytona record holder Floyd Emde's tail at this TT course event in Fox Canyon, south of La Cumbre Junior High School. To quote Mills: "I passed Emde twice that day but only because he let me, you know, to put on a show for the crowd and all." (Courtesy of Marsha Mullaney Novak.)

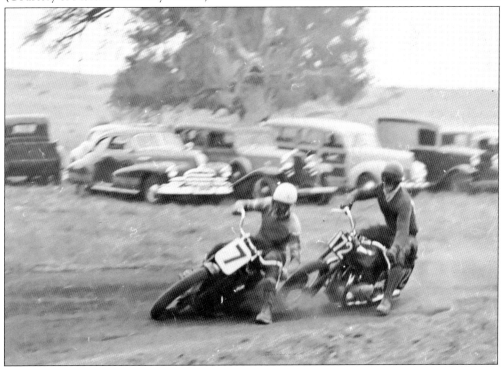

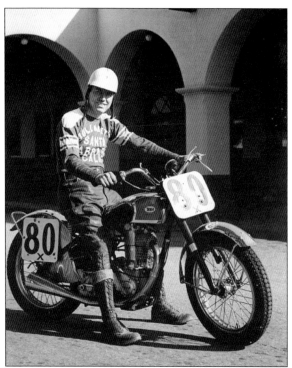

If the building in the background looks familiar, that's because it is the Santa Barbara train station. Built in 1905 in the Mission Revival style, it soon became a popular backdrop for photographers. Bob Mullaney is pictured on his new BSA. When Indian motorcycles stopped production in 1953, Mullaney's motorcycle shop turned to BSA. (Courtesy of Marsha Mullaney Novak.)

Most in their youth had a hangout, usually a hamburger joint. In Santa Barbara in the 1940s, Sunseri Brothers at 324 West Cabrillo Boulevard was one of the best, right on the beach. It is pictured on a Saturday afternoon, and everybody is there. Danny Patton (front) and Gifford Fox are on the first bike. Looking around from behind them is Bob Mullaney. (Courtesy of Marsha Mullaney Novak.)

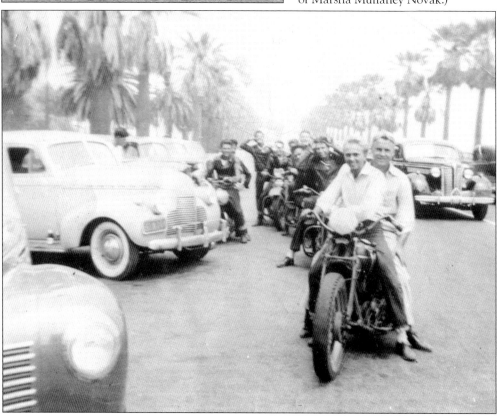

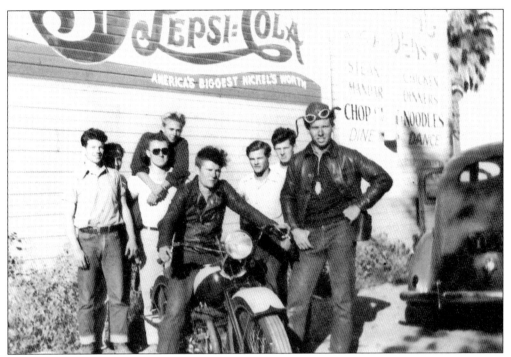

On a Sunday afternoon, the boys are just hanging out at Sunseri Brothers hamburger joint on Cabrillo Boulevard. The lot is right next door in the 300 block. From left to right are Putty Mills, Johnny Simmons (behind Putty), Gifford Fox, with Danny Patton on his back, Bud Rogers (on motorcycle), Dwight Priest, Bob Snow, and big Henry "Huck" Kuzen. (Courtesy of Guy Duckett.)

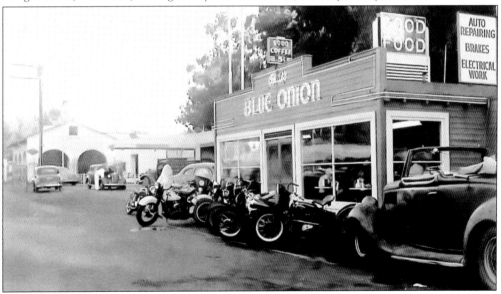

Those who grew up in Santa Barbara in the 1940s, 1950s, or even the early 1960s knew where a Blue Onion was. There were several, and they were always the place to go. This one was at 834 Coast Highway (now known as Old Coast Highway) in Montecito. Pictured is Bob Snow's 1936 Ford convertible. Coffee was 5¢, the best-spent nickel in town. These were the good times. (Courtesy of Guy Duckett.)

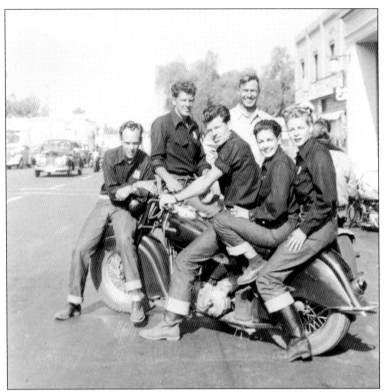

Some of the members of the Santa Barbara Motorcycle Club are pictured at a field meet in Corona, California. Piled on a 1946 Indian Chief are, from left to right, Jack McNally, Bob Snow, Putty Mills, Huck Kuzen, Mary "Chili" Galera, and Johnny Johnson. Chili would become Mrs. Mills, and Jack would soon wed Johnny. (Courtesy of Bob Snow.)

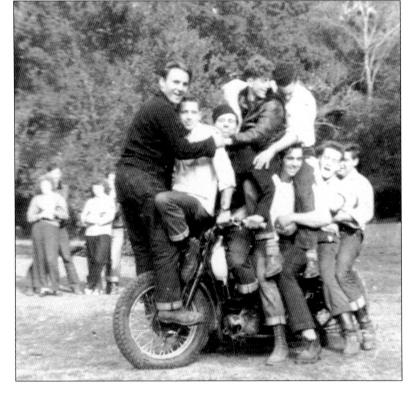

Those were good days to be young and it was an era of "let the good times roll"—and they did. How many people can you get in a phone booth? I don't know but I'll bet we can get nine of us on a Harley-Davidson! (Courtesy of Bob Snow.)

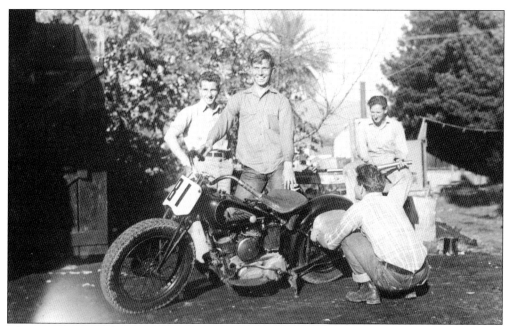

The war is over and everyone is smiling, especially the big fella posing with his Indian Scout. From left to right are Jimmy Clearwater, Huck Kuzen, Rhys Price (installing the placard), and Don "Ducker" Burge. The stamp on the back of this photograph indicates it was developed at Anderson's Camera on State Street on February 13, 1946. (Courtesy of Marsha Mullaney Novak.)

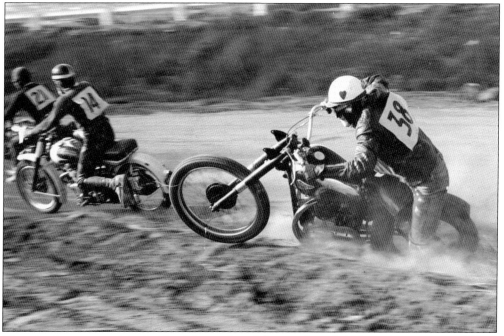

There is a berm around the inside of the track to delineate the infield from the racecourse. When a wheel comes in contact with an angled surface, it will sometimes try to climb it. It appears that Tony Rios is learning this theory firsthand as he comes out of a turn a little too tight. Rios has broken off relations with the motorcycle seat for now. (Courtesy of Jeanne La Berge Rios.)

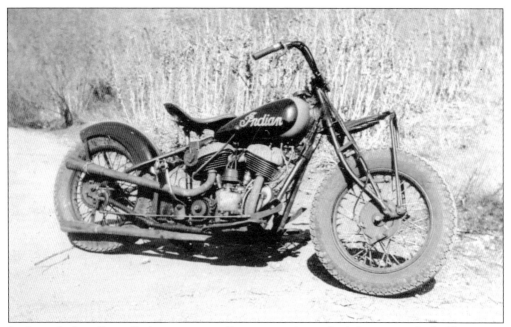

In the early days, Santa Barbara was a smaller town, and everybody knew everybody. If someone wanted to take a ride on another guy's bike, it was okay—especially if that bike belonged to Hook Klein. This early Indian Chief was Klein's, and in the pages of this book, it is seen often, and always with a different rider. (Courtesy of Tony Rios.)

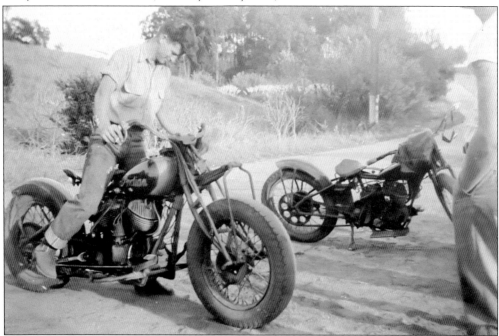

Putty Mills is admiring Hook Klein's big Indian Chief at a practice spot off Modoc Road. Putty's Harley 45 is in the background. The early Indian Chiefs, and earlier 101 Scouts, used an inverted leaf-spring suspension. As the front wheel was pushed up, the linkage would pull down on the spring. (Courtesy of Putty Mills.)

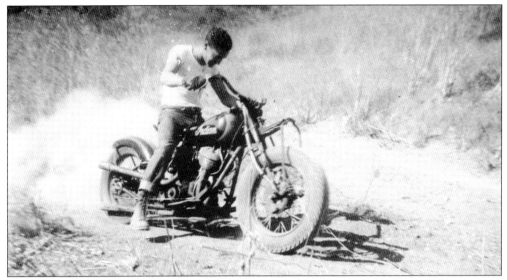

Tony Rios sits on Hook Klein's prewar Indian Chief at the Veronica Springs course off Las Positas Road. After World War II, Indian would abandon the semi-elliptic leaf-spring front suspension seen in this image for a coil-spring type. Indian stopped production in 1953 until the name was purchased by a British group. (Courtesy of Jeanne La Berge Rios.)

October 23, 2001, would be the last time these three were together. From left to right are Hook Klein, Putty Mills, and Elmer Black. Hook had left for Studio City in 1941 and had not been seen for years. Elmer finally found him, and for Hook's 90th birthday, Elmer and Putty went to see him. In Putty's words, "when Elmer and I walked in the door, Hook broke down and bawled." So long, Hook. (Courtesy of Phyllis Black.)

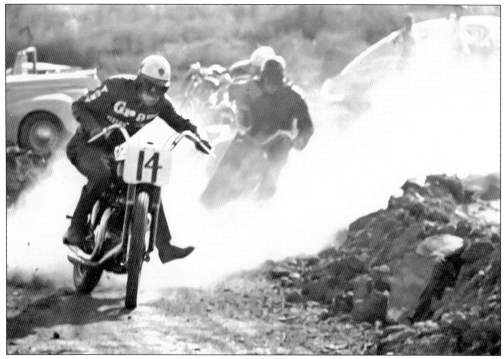

This image shows Tony Rios balancing on one foot-peg as he comes up over a curve at an unidentified Southern California dirt track sometime in the late 1950s. By this time in his career, Tony had acquired a sponsor—Grant piston rings, whose name is displayed on his leather jacket. Note how the exhaust pipes have been directed to one side for TT racing. (Courtesy of Jeanne La Berge Rios.)

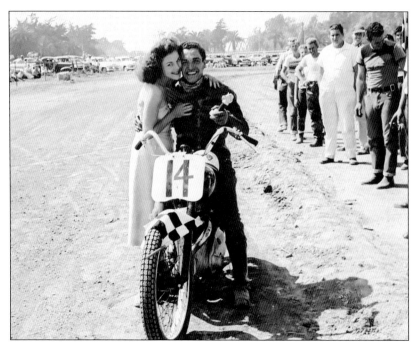

Tony Rios is smiling from ear to ear and for good reason: He has a checkered flag draped over the front wheel of his motorcycle, he has a trophy in his left hand and a girl in his right hand, and 15 young boys are looking on and wishing to heck they were him. (Courtesy of Jeanne La Berge Rios.)

The young men in this group celebrating Tony Rios's 21st birthday would go on to live out their lives and form careers in Santa Barbara County. Bob Mullaney (top left) would assume proprietorship of Mullaney's Motorcycle Shop and teach auto mechanics at San Marcos High School. Harvey Pierce (lower left) would become a Santa Barbara police officer, assigned to the motorcycle patrol division. Tony Rios (center) would learn the heavy equipment trade and become a diesel mechanic. In 1966, he would purchase a 47-foot sword-fishing boat known as the *Spaniard*; Tony operated the *Spaniard* for the next 26 years. In 1950, Putty Mills entered the partnership of Edwards-Mills, Inc., a Willys dealership at 318 State Street. Mills earned his commercial pilot's license and chauffeured would-be moon-landing astronauts to training grounds in Colorado, then instructed them in driving the lunar rover. These celebrants would all remain motorcycle enthusiasts throughout their lives and go down in their retirements knowing that they left an indelible mark on motorcycling in Santa Barbara County. (Courtesy of SBMC.)

Discover Thousands of Local History Books
Featuring Millions of Vintage Images

Arcadia Publishing, the leading local history publisher in the United States, is committed to making history accessible and meaningful through publishing books that celebrate and preserve the heritage of America's people and places.

Find more books like this at
www.arcadiapublishing.com

Search for your hometown history, your old stomping grounds, and even your favorite sports team.

Consistent with our mission to preserve history on a local level, this book was printed in South Carolina on American-made paper and manufactured entirely in the United States. Products carrying the accredited Forest Stewardship Council (FSC) label are printed on 100 percent FSC-certified paper.